Plaster Studio

Mixed-Media Techniques for Painting, Casting and Sculpting

Stephanie Lee & Judy Wise

NORTH LIGHT BOOKS
Cincinnati, Ohio
www.CreateMixedMedia.com

15 14 13 12 11 5 4 3 2 1

Distributed in Canada by Fraser Direct
100 Armstrong Avenue
Georgetown, ON, Canada L7G 5S4
Tel: (905) 877-4411

Distributed in the U.K. and Europe by F+W Media
International
Brunel House, Newton Abbot, Devon, TQ12 4PU,
England
Tel: (+44) 1626 323200, Fax: (+44) 1626 323319
Email: postmaster@davidandcharles.co.uk

Distributed in Australia by Capricorn Link
P.O. Box 704, S. Windsor, NSW 2756 Australia
Tel: (02) 4577-3555

Library of Congress Cataloging-in-Publication Data

Lee, Stephanie (Stephanie Lynn),
 Plaster Studio : Mixed-Media Techniques for Painting,
Casting and Carving / Stephanie Lee and Judy Wise.
-- First edition.
 pages cm
 Includes index.
 ISBN-13: 978-1-4403-0815-4 (pbk. : alk. paper)
 ISBN-10: 1-4403-0815-2 (pbk. : alk. paper)
 1. Plaster craft. I. Wise, Judy. II. Title.
 TT295. L44 2011
 730--dc22

 2010043144

fw media
www.fwmedia.com

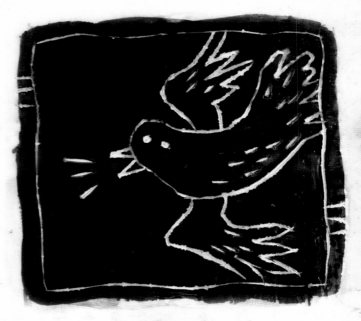

EDITOR:
Tonia Davenport

DESIGNER:
Geoff Raker

**PRODUCTION
COORDINATOR:**
Greg Nock

PHOTOGRAPHER:
*Christine
Polomsky*

Dedications

To my family wide and vast. To each and every friend who has encouraged and inspired me and stepped into that ever widening circle of my family. To all my parents for loving me with a depth and spirit that makes me want to live a happy and full life in honor of you.

Most of all, to my best friend and husband, Vincent, and to my daughters, Melissa and Annabelle, who willingly pick up the slack on the home front when I'm knee-deep in this creative life, who don't mind eating on the sofa when the dining table is overrun with plaster mess, and who saunter into my studio when I'm working with genuine interest in what I'm up to. For their love and support and dinnertime laugh-until-we-cry sessions, I am eternally grateful.

—Stephanie

To my husband and best friend, John Prescott, and my daughters (and best friends), Shellie Garber and Stephanie Garber, for trusting my love despite the fact that I often painted right through meal preparation and supper time. And for helping me sell my work at art fairs across the country for three decades—what a mighty effort it was. You each have made my art life possible, and I am deeply grateful for your support and for understanding my art affliction. You are always in my heart.

—Judy

Acknowledgments

From Stephanie:

To Judy Wise for her depth of knowledge and love for exploration and for being a willing accomplice in this adventure. She is one of the most real, honest and inspiring people I know.

To each and every hand that has been involved in the making of this book. From those at North Light who made it real, to the retreat organizers who have had faith in what I have to offer, to the students and dear friends whose courageous exploration inspires and uplifts me. I thank you all from the heart of my heart.

From Judy:

To Stephanie Lee for her knowledge of the medium and for being a great co-explorer on this fascinating search. She knows her way around a hardware store, a quality I most admire.

To Tonia Davenport, our editor, for being a nurturer of writers and art makers.

To the creative minds at North Light and especially to our art director, Geoff Raker, for making the book beautiful.

To Diane Havnen-Smith, Katie Kendrick, Teesha Moore and Glenny Demson Moir for encouraging me to teach.

For being my muse, eternal friend and life coach, I thank Guy Stiles.

And to all the artists and students I have met while teaching and traveling, you have kept me inspired and given me immeasurable joy through your generous friendship and love. You have given me the gift of relevance and the message that I have something worth sharing with others. For all of these acts of kindness, I am immeasurably grateful.

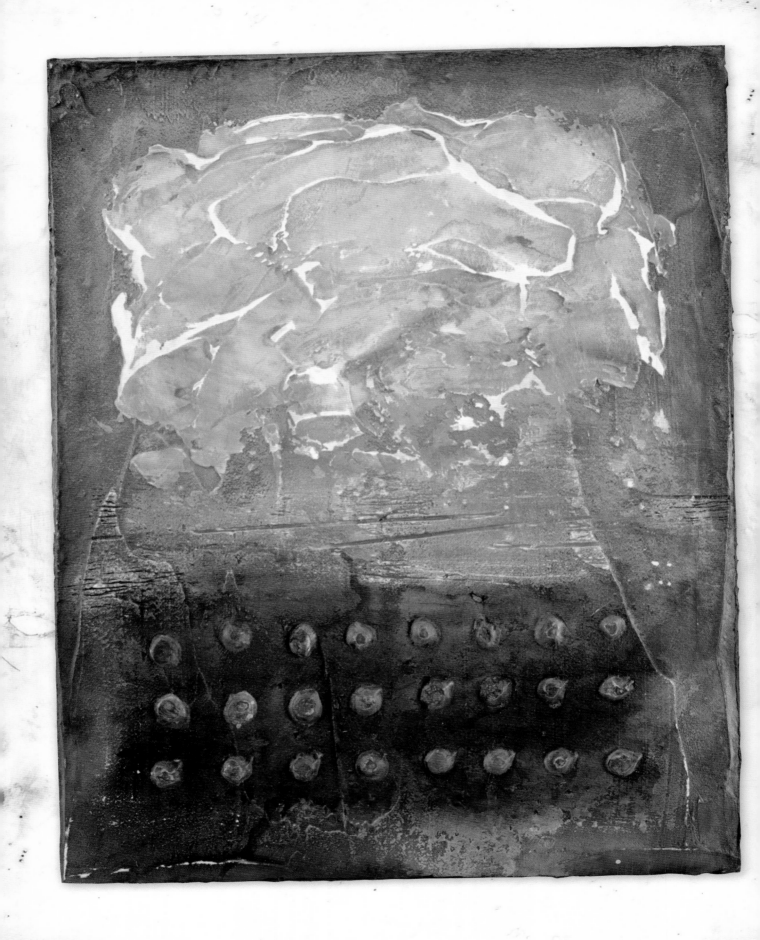

Contents

Raw Material, Renewed Inspiration

Gathered from the generosity of the earth, plaster holds within it an inherent and noble connection to history. It has remained virtually unchanged for thousands of years in regard to its use in art and architecture, yet we two artists—who love plaster for the receptive medium that it is—have more than once experienced the newness of it. You have a powder and you add water. But oh, the variety of projects that can emerge from such simple materials! Plaster teaches us something new each time we explore it, and so the gift of discovery is around every turn.

Surely we all have somewhere a lump of plaster into which a young child has pressed her hand. A moment in time, a gift for mom, a beaming and proud young artist. Houses that many of us have lived in are or were made of stucco, another plaster-and-cement product, troweled over a supporting layer of chicken wire. Again, material so elemental that most of us could easily imagine the steps necessary to construct this shelter.

If you were to stop us on the street and ask what it is about using plaster in our artwork that is so satisfying to our creative urges, you'd be wise to have a comfy chair handy because the list of reasons is not a short one. It's not a linear list either. It's a circular list. It loops around and across and back up and around itself again as we begin to explain how plaster responds to paint, how well it marries to other surfaces and back again to how, when painted, it marries to itself. The layers of possibility are stacked one upon another when you slice through the strata of our idea-incubating minds.

We might even start to get a bit animated when we move into telling you about the possibilities of three-dimensional form. We'll nod our heads emphatically at what the other is saying and resist the urge to let the ideas being sparked in that very moment of conversation take over our minds and bodies and pull us to the studio to make it happen—now. The love affair is that great, that inspiring, that pure. How else is a medium more serving than if it awakens a youthful excitement to the approach of creative play?

Plaster is one of the most versatile and adaptable mediums we know. Like other art mediums—paint, pastels, clay—its origin is the earth but unlike many other art mediums, it is almost in the same form as it was found. Here we are using a material so raw and cooperative and willing to be altered, we can't help but feel a return to simplicity. It's a return to art that is more about expression and less about trend. A return to the unpretentious boldness of playing in mud and seeing what will happen.

This isn't to say that the simplicity of the medium is without depth. There is a luminosity to plaster that cannot be duplicated, and often we are surprised by how much the plaster gives back in that regard when we seem to do very little to alter it. A simple paint wash brings texture to life. A bas-relief carving showcases the depth. A layer of encaustic medium over plaster makes it appear as though it is softly illuminated from within. For every single stroke of paint we give to the plaster, the plaster gives back tenfold in depth and richness and history.

In this book we present an approach to working with plaster through the isolation of individual techniques and specific project creation. As curious artists, our tendencies are to layer and experiment and layer some more, combining one process with another and another. We encourage you to combine the techniques learned in the projects and see for yourself how easily plaster lends itself to surface design, casting, carving, sculpture and the book arts. It is our sincere hope that through the exploration of these techniques, a renewed sense of curiosity will be ignited, and we hope to entice you in ways you've never even dreamed.

So go on, get your plaster on! You have no idea what you're in for!

—Stephanie and Judy

Plaster: What Is It?

Plaster is one of the oldest and most useful of all the materials used by artists. Guilds of Italian craftsmen dating back to Roman times made decorative moldings and wall reliefs to adorn important buildings. Various techniques include marmorino (crushed marble and lime putty applied to walls and columns), scagliola (inlay work), sgraffito (scraped work revealing underlying color) and, in Marrakech, a technique where stones burnished the plaster and brought up a glowing, tightly packed surface that was nearly waterproof. These techniques, in addition to many others, are still in use by designers today.

In addition to decorative interior work, plaster has found favor among clay artists as a casting material, among painters as a substrate for mixed media and as a material that can be sculpted and cast in a number of innovative ways.

In order to understand the properties of the materials with which we'll be working, it is a good idea to familiarize ourselves with the various materials we call plaster. Without getting into the chemistry (which we don't fully understand ourselves), here is a simplified but helpful guide.

One way to think about the family of plasters as a whole is to divide them into three types: gypsum, lime and cement plasters.

For the most part, lime plasters and gypsum plasters behave the same with the main difference being that gypsum plasters are a bit softer when cured than lime plasters. Additives, such as wood glue, can be mixed in with gypsum plaster to increase hardness. Cement plasters are ideal when creating artwork for outdoor use.

We will be working with gypsum-based plasters in this book, specifically with plaster of Paris, plaster wrap (which is plaster-impregnated gauze) and joint compound.

Plaster of Paris

Gypsum deposits from the Montmartre district of Paris, France, gave this soft, naturally occurring mineral its name. The mineral is heated to 150° C to create the dry product we call plaster of Paris. It is composed of calcium sulfate dihydrate.

The hardness of plaster of Paris can also mimic carved wood when sculpted, as we have done with the Foam Santo on page 82. Once water is added to dry plaster powder, a reaction is initiated that cannot be reversed, so it is best to have your substrates prepared ahead of time. Add enough water to the powder to mix it just until combined and then apply to your substrate. The longer you mix it in the container, the faster it will set up. Once it has begun to set up, you cannot reconstitute it to liquefy because it is the effect of the chemical reaction that hardens it, not that it is drying out. One tip: Do not use a wooden stir stick unless you plan to use it only once. A plastic spoon is best. Also, any hardened plaster on your stir stick or in your container will drastically accelerate the hardening time of any subsequent batches mixed.

Plaster hardens as a result of a chemical reaction that is initiated once the water is added to the plaster. This reaction has its own schedule to keep and can be hurried along only so fast. Using warm water to mix with the plaster will speed the set time up (and also shorten your working time), but blowing set plaster with a hair dryer will do little to nothing to cure set plaster. The water just needs to evaporate in its own time.

When using plaster of Paris, understanding the process of curing will enable you to use the medium in the way you want to. We've broken the stages to three main stages. Simplified, they are wet, set, cured.

"Wet" means the plaster is mixed with water and still totally malleable. It may be runny and able to be poured into a mold, or it may be just thin enough to spread with a trowel onto a substrate with many stages in between. The wet stage will usually be within the first 5–10 minutes of adding the water (less time if you use warm or hot water).

The plaster will soon start to harden and get to where you can't work it any more with a trowel or another tool. This is the "set" stage. It means that the plaster is hard but still holds all the moisture from the water.

"Cured" plaster is plaster that no longer holds any moisture from the water that was added to it. The cure time varies greatly depending on ambient humidity and temperature with a dry, warm environment being the ideal setting for the quickest cure possible. Most curing happens within twenty-four hours of the initial mixing. The ideal stage to paint is when the plaster is cured.

Gesso and Chalk

Calcium carbonate is the mineral that is the active ingredient in both gesso and chalk, and goes by the name of dolomite, limestone or agricultural lime. It is alkaline and used to increase the pH of acidic soils among other things. When mixed with a binder, it becomes gesso and is the main ingredient in chalk. It is also in the gypsum category.

Quicklime

Quicklime is calcium carbonate that has been heated to 825° C in a lime kiln. It is alkaline and highly caustic. Water can be added to produce slaked lime, the material used in lath and plaster walls and in frescos where dry pigments, diluted in water, are painted onto the wet plaster. Paint (limewash) can also be made by adding colorant to the slaked lime.

Joint Compounds

These are premixed building products with long lists of ingredients. There is a huge range of variation both in set time, softness, paint absorption and labeling, so experiment all you can to find what you prefer.

The main advantage to using joint compounds is that you can find buckets premixed and ready to apply, hence avoiding the dusty mess of mixing plaster of Paris. However, it has a much slower drying time than plaster of Paris and can also be washed away with too much rubbing of a damp rag or water as when applying a gel medium transfer.

We like the gallon tubs of standard joint compound (also called drywall mud) and have tried a number of different brands with the main difference being setup time. From brand to brand you'll notice slight color variations when it's dry with a range from bright white to pale gray to warm ecru. For photographic purposes, the projects in this book use a joint compound that is pink when wet and dries white. If you are painting the plaster, generally the color won't matter, but if you are leaving it raw and exposed in areas, you may want to take this into consideration.

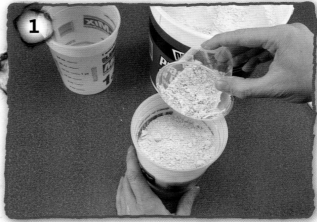

Measure out the plaster powder.

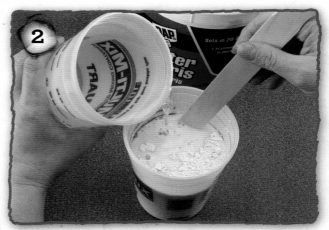

Add water.

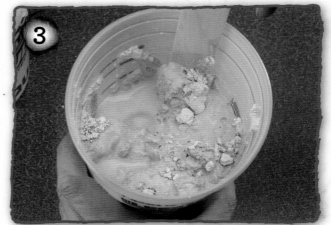

Mix, using a paint stirrer or a large plastic or metal mixing spoon.

Tools and Materials

Plaster of Paris

Sold in various quantities at art, craft and hardware stores. This is a dry powder that you will mix with water. It is harder than joint compound and ready to paint within an hour in a warm environment.

Joint Compound

Sold both as a powder to be mixed with water or as a pre-mixed mud. We prefer the premixed buckets. Joint compound is softer than plaster of Paris with more open working time. Plan to leave it for a few hours (up to overnight) before painting.

Plaster Gauze

Sold in individual rolls or in bulk (boxed), this open weave fabric strip is impregnated with plaster of Paris. To activate the plaster, simply dip the plaster gauze in water (warm to accelerate hardening time or cold to slow it down) and apply to your substrate.

Trowel

Plastic or metal paddles made specifically for applying joint compound to walls with either a flat or toothed edge. Available at hardware stores. Credit cards or offset spatulas can work in place of a trowel in most applications.

Substrates

For the most part, any wood substrate will work: panels, art boards, frames, boxes and scrap plywood. When combined with plaster on burlap, stretched canvases will work as well. (You cannot spread plaster directly on stretched canvas. Once it dries, it will be too brittle to stay attached.)

Corrugated Cardboard

When wrapped with plaster gauze first, you can use cardboard as a substrate on which you can apply more plaster, paint, encaustic, collage and more.

Acrylic Paint and Paintbrushes

Experiment with different brands and quality. You'll notice in the projects in this book that we use a variety of paint for the various effects we can achieve. In general we prefer a matte finish on plaster, and craft paints are good for this.

Gel Medium

For transfers, it is best to use an artist-grade soft gel medium. For collage on plaster, you can use gel medium or other preferred glue.

Clear Gesso

Very few companies make clear acrylic gesso. We prefer the Liquitex brand for how clear it dries and for its chalky texture that mimics the plaster (rather than one that is more slick and plastic-like when dry).

Sandpaper

You can purchase different grits of sandpaper at any hardware store. Sandpapers that are more coarse will scratch the plaster, and papers that are more fine will create a smoother finish. For the projects in this book, the sandpapers we use range from 120- to 200-grit.

Scotch-Brite Green Scrub Pads

These are wonderful for removing paint off the surface of plaster without scratching the plaster. Also, with the cracked burlap technique, you can remove all the surface paint, leaving it only in the cracks. These can also create a really smooth surface.

Stir Sticks

We recommend using plastic or metal. Wooden paint stirrers like to bond with the plaster more and can create problems when mixing multiple batches of plaster of Paris, and so are best when used just once.

Mixing Container

Flexible plastic containers are best. If extra plaster of Paris hardens before you are able to use it, just let it harden and then squeeze the cup out over a garbage can. The plaster will pop right out. Be sure to wash out the container between uses.

Stabilo Marks-All Pencil

A water-soluble pencil that can be blended with gel medium or water.

Oil Sticks or Oil Bars

There are different formulations of sticks or bars that range from solid to soft and oily. They are handy for applying to intaglio lines scratched into wax and can be used alternatively with oil paint from tubes for the same purpose.

Graphite

A mineral available as pencil leads of varying thickness or stick form depending on the line quality desired. Graphite comes in varying hardnesses ranging from 10H (hardest and lightest value) to 9B (softest and darkest value). If you've never drawn with a fat graphite pencil that leaves a very dark line, we encourage you to try it. Graphite is lovely on plaster and can be rubbed for shading effects.

Watercolor

Colored pigments mixed with gum arabic or other water-soluble binders. Check for colorfast ratings if you are doing professional work as some of the older colors are fugitive (not lightfast/nonpermanent).

Thermal Foil

This is a product that is used shiny-side up to transfer metallic foil to a waxy or tacky surface. The foil is attached to Mylar, and with a little pressure, it detaches from the Mylar and forms a bond with the wax. Available in sheets or rolls.

Encaustic Medium

A mixture of clear beeswax and damar resin crystals in an 8:1 ratio. The beeswax will melt at about 150° F (66° C), and the resin will melt at 225° F (107° C), so it is important to keep an eye on the procedure. The resin comes in amber colored "rocks" mixed in with bark and dirt, so after mixing the ingredients it is necessary to strain the medium. We prefer inexpensive paper paint strainers from the hardware store to remove the impurities. When using this medium, use a dedicated brush. Encaustic medium is used with a hot pot, such as a mini Crock Pot, or in an electric skillet.

Electric Skillet

We like the skillet because it is easy to work over the wide opening and because of the temperature control. Your wax should never be hot enough to smoke, so use a thermometer if you need to with your appliance.

Burlap or Other Open-Weave Fabric

A fibrous fabric with an open weave that bonds well to plaster of Paris and enables you to create a cracked surface or smooth surface when applied to stretched canvas or other substrate.

Wood Glue

Wood glue can be mixed with joint compound or plaster of Paris to create a harder, final finish and better bond with some substrates. Any brand will work.

Two-Part Epoxy

Used to attach cast plaster objects to substrates. Any brand will work.

Butane or Propane Torch

Used to bubble paint on wood and plaster. The torch with the largest flame will give the best results.

Rebar Tie Wire

Used as an armature for creating vessels, cages and more. Sturdy and readily available.

Wood Carving Tools

These work great for mark making and carving into the plaster for depth and interest.

Basic Art Kit

Masking tape, craft knife, scissors, cutting mat, heat gun, pliers, wire cutters, plastic table cloth or bags, collage elements and paper ephemera.

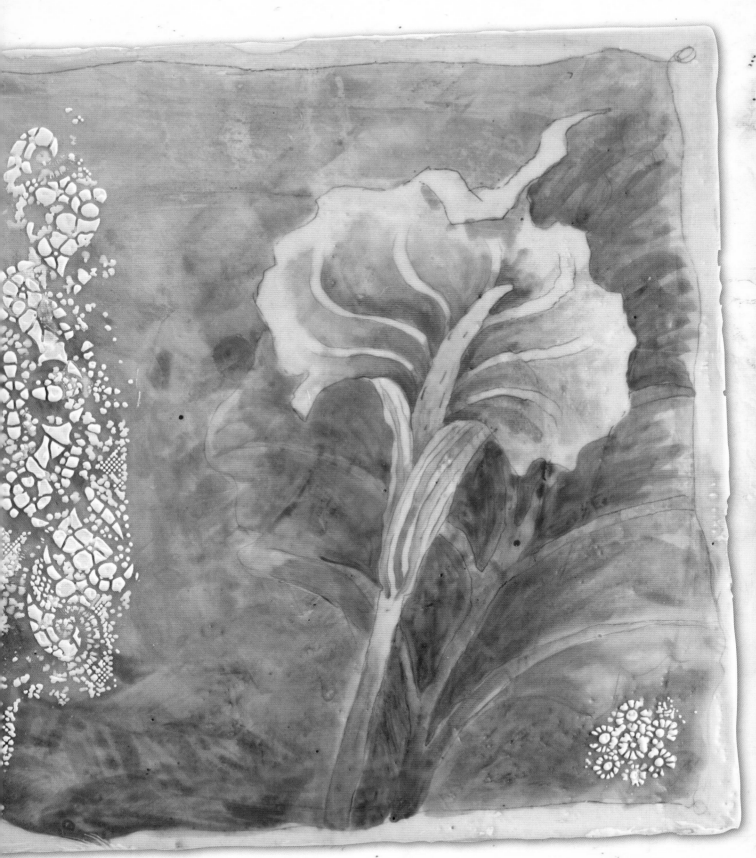

Painting on Plaster

Plaster is a luscious, absorbent surface—comparable to the texture of an eggshell—and it loves graphite and paint. The slight tooth it has grabs the graphite or paint pigments and shows off the texture to great advantage. Watercolor added to the drawn line is beautiful too, showing the overlapping edges of each stroke in the way that majolica glazes behave on fired ceramic. These thin layers of paint highlight the reflective quality of the plaster substrate.

For a more opaque effect, try a matte acrylic paint thinned to the consistency of milk or light cream. It's generally a good idea to avoid the glossier paints because plaster itself is matte and we won't want to hide its natural beauty.

True fresco as well as limewash has a unique glow due to the refraction of calcite crystals. Some painters who work on plaster of Paris or joint compound add marble dust to their acrylic paint to try to approximate this effect. In fact, experimenting with various formulations of paint on plaster can be a fascinating search. It can be fun to get a bag of marble dust from an art supply store and experiment with various recipes.

Since plaster or joint compound is relatively soft, even after setting up, it is easy to scratch the surface with a wire brush, sandpaper or carving knife. Thus layers of color can alternate with surface abrasion as areas are scratched away to reveal underlying layers. Adding, removing, distressing and layering are only four reasons that painting on plaster can be such an exciting and surprising adventure.

Let's get started with a few suggestions that will start you thinking about the endless possibilities of the medium.

Plaster Additive

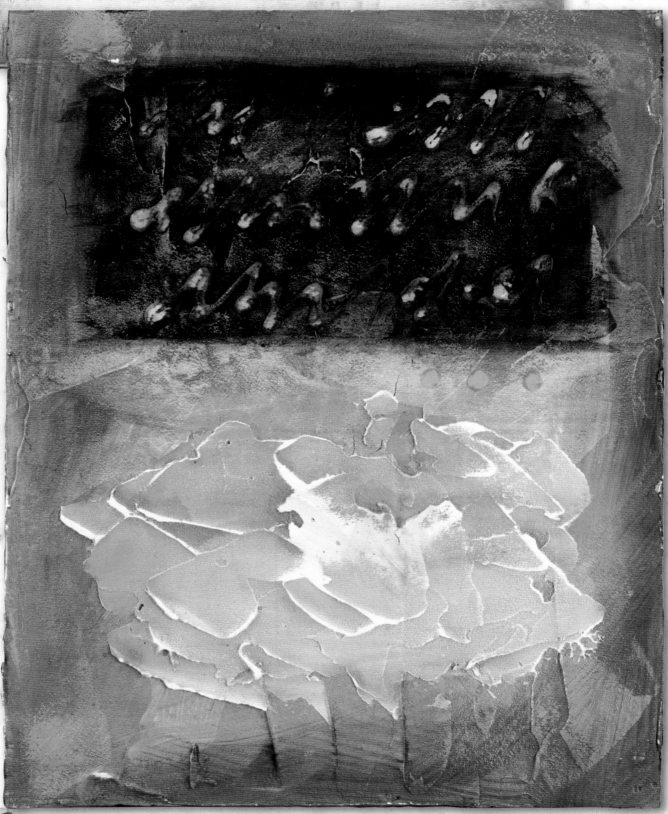

In this project we'll focus our attention on things we can do by adding plaster to a plaster painting. It's a good idea to prepare the board an hour or two before you begin to paint so the joint compound has time to set up. In these photographs the joint compound is pink when it's wet and dries white so you can tell easily when it is safe to go back in with paint. A plastic squeeze bottle will allow you to control the joint compound so you can write words with it or just scribble on a random design as I have done.

—Judy

Materials

- trowel
- joint compound
- wood panel
- paintbrush
- acrylic gel medium
- acrylic paints
- plastic squeeze bottle
- sandpaper

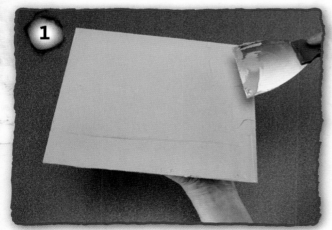

Using a trowel, spread joint compound onto the panel. Allow the joint compound to dry. Note: The plaster may be colored like it is here when it´s wet, but it will dry white.

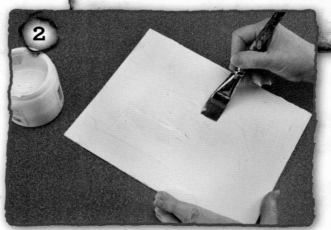

With a dry paintbrush, apply gel medium to the joint compound surface, only in the area you want the resist—a flip-flop technique. Allow the medium to dry.

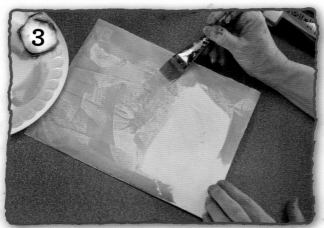

Create a color wash from your desired colors of acrylic paint. Wash over the entire surface.

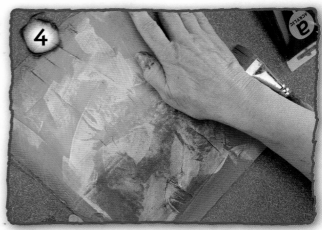

Add more paint colors as desired. Use your hand to soften the edges and control the amount of paint. Allow the paint to dry.

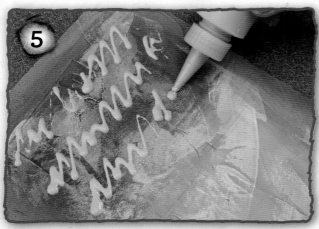

Mix some joint compound with water and put it into a fine-tip plastic squeeze bottle. Squeeze the mixture onto the surface in the desired design.

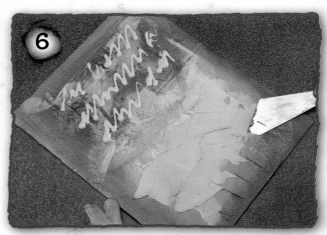

Apply more joint compound for some added texture, using the palette knife. Allow the joint compound to dry.

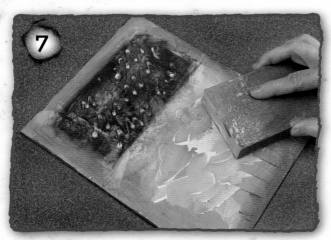

Paint as desired and allow the paint to dry. Sand the surface a bit to add highlights to the texture.

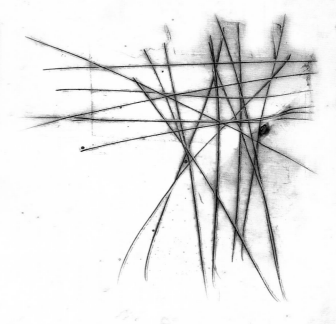

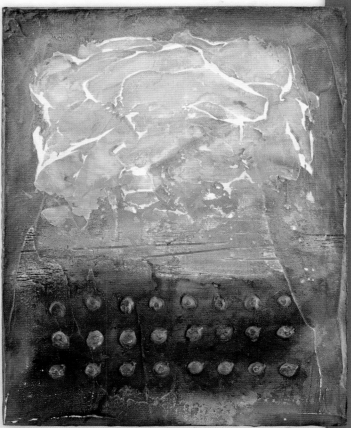

Crop Circles
Judy Wise

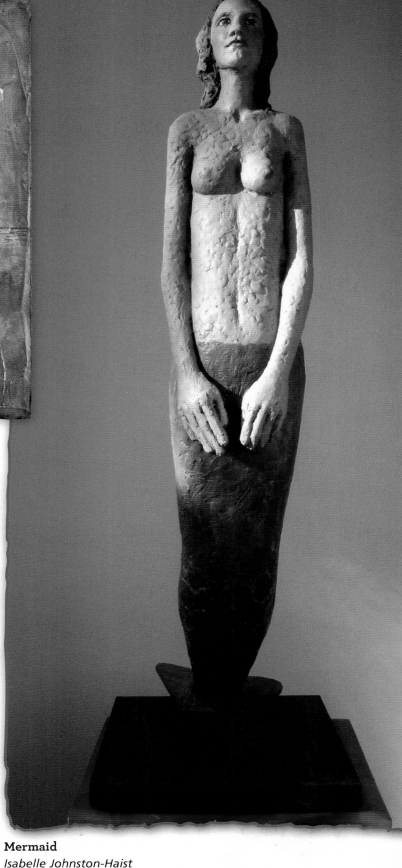

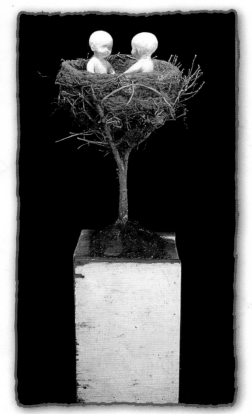

Parabellein
Heidi Petersen

Mermaid
Isabelle Johnston-Haist

Image From Tissue

A simple way to add a copyright-free illustration (or your own drawing) is to print it out in reverse on tissue paper with your ink-jet printer. To do this, adhere white tracing paper to a sheet of ink-jet paper by making the tracing paper slightly smaller than the ink-jet paper and then adhering them together on the top and two sides with a glue stick. Run them through your ink-jet printer and immediately release the tracing paper by sliding a letter opener or palette knife between the sheets.

I always like to adhere the image ink-side down on the plaster to keep the ink from smearing when I paint over it.

—Judy

Materials

- plaster of Paris (including mixing container and paint stirrer)
- trowel
- wood panel
- découpage medium (ModPodge)
- craft brush
- image printed on tissue paper
- paper towel
- acrylic paints, assorted colors
- sanding block
- scribing tool or awl
- painting knife (optional)

1 Prepare plaster (see pages 8–9) and trowel it onto the wood panel. When it has set, use a thin layer of decoupage medium to adhere the image ink-side down onto the plaster surface.

2 Lay a paper towel over the image and use your hands to burnish/smooth the image onto the surface and work out any bubbles. Let the medium dry.

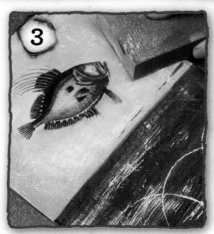

3 Embellish by painting, sanding and scoring the surface as desired. I used a green paint and sanded lightly to distress the plaster and then used a bottle lid as a guide to scribe in semicircles. I lightly tapped in the line of red paint using the edge of a painting knife.

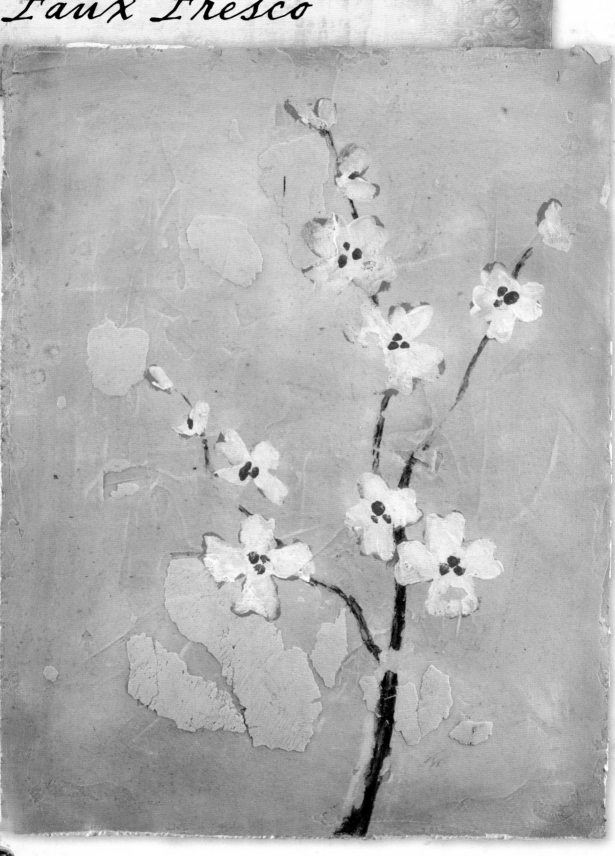

Though I've yet to experience a European country firsthand, I love photographs of buildings hundreds of years old, rich with texture and history. Images of old fresco walls—created back when painting a wall in your home was more than slapping on some trendy color with a roller—inspire me endlessly. I want to mimic the depth, luminosity and story of each expanse of wall.

Here I show you how to create your own small version of a faux fresco wall, but feel free to work as large as you'd like. In fact, take it to the wall itself, if you dare, using the same techniques. Who says art is just for mounting on a wall? Let the art BE the wall!

—Stephanie

Plaster Prowess

When I know I'm going to be sanding a plaster surface, I prefer inexpensive acrylic paints. Rather than acting like a plasticy skin, they are super-chalky (which is what I love about plaster and don't want to cover up) and seem to bind with the plaster better than higher-grade artist acrylics.

Materials

- joint compound
- heavy watercolor paper (140 lb. [300gsm] or heavier)
- trowel
- acrylic paints (including Burnt Umber)
- wide paintbrushes
- dry rag
- wet rag
- plaster of Paris (including mixing container and paint stirrer)
- tub of water
- chalk pastels
- detail paintbrushes
- gel medium (I prefer soft gel matte)
- clear acrylic gesso

1 Drop a glob of joint compound on the substrate.

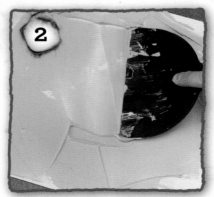

2 Use a trowel to spread the joint compound over the surface. Be sure to use firm pressure with the first few swipes of joint compound to make sure it will bond well with the substrate.

3 Continue spreading until you have a smooth surface with good coverage.

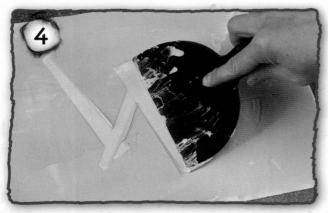

Make random gouging marks in the joint compound with the edge of your trowel.

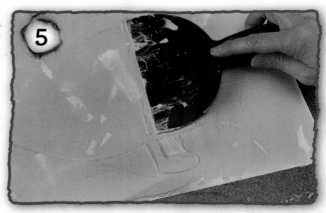

Float (spread with light pressure so as to keep some of the texture in place and smooth out some areas lightly) the trowel over the gouge marks to blend them in a bit without filling them back in. This creates highs and lows in the surface, which mimic years of patched plaster on a wall.

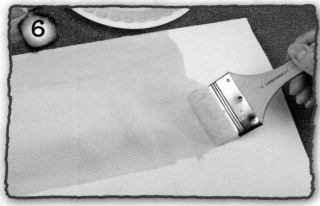

Once the joint compound is completely dry, mix watered-down paint into a wash. Apply over the entire surface with a wide brush.

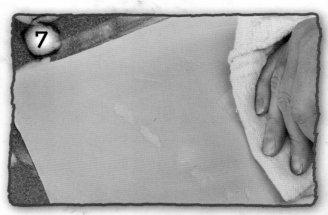

Using a dry cloth, wipe up any excess paint and moisture that is on the surface.

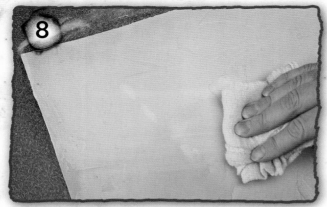

Do the same thing with your damp cloth to remove a bit more of the paint, revealing the texture of the joint compound. Allow the paint to dry completely.

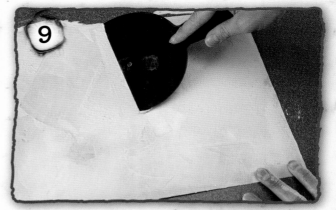

Mix up a small batch of plaster of Paris according to the manufacturer's directions. Use the trowel to spread a very thin layer of plaster over the painted joint compound. This will fill in the low spots, allowing the high spots to show through. Allow to dry thoroughly.

Bend the paper backward to help crack the plaster. Some of it will pop off and will add to the aged and timeworn effect.

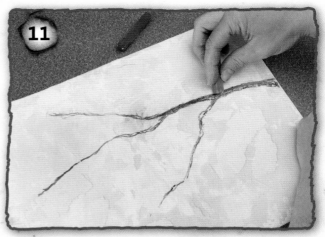

Using a clean, damp rag, gently wipe over the surface. Use chalk pastels to embellish the background or create imagery, such as a loose branch.

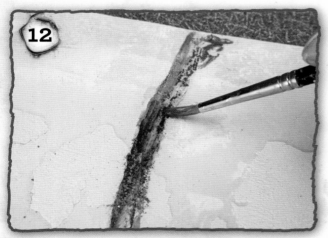

Use a paintbrush to blend a bit of gel medium into the chalk to bind the chalk to the painting. Allow the gel medium to dry.

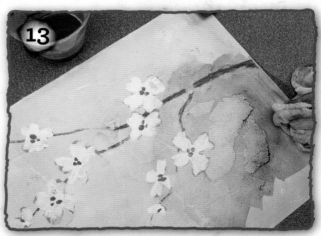

Create a wash of Burnt Umber paint and water. Paint over the entire surface with a wide brush. Quickly wipe off the excess paint to reveal an aged surface. Let dry, then apply a final coat of clear acrylic gesso. (I prefer the Liquitex brand for how clear it dries and for its rugged tooth, which mimics raw plaster while still protecting it.)

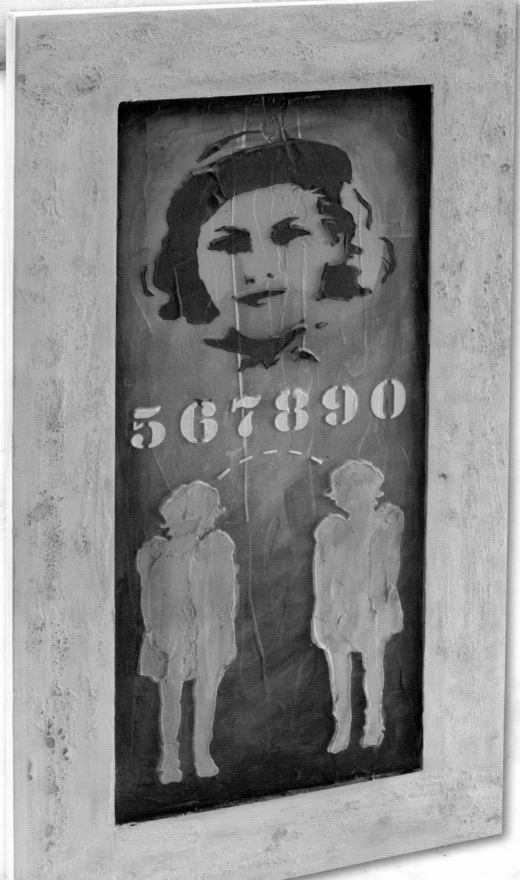

Joint compound loves stencils. The ones I used in this project were cut out of heavy paper and Mylar. If you use paper, it's a good idea to spray paint both sides first to reduce absorbency and then to plan on a one-time use. Mylar or acetate can, of course, be rinsed off and used more than once. If you do rinse, don't forget to do it in a bucket and not right down the drain. Plaster will harden in your drain just as it will on your project.

—*Judy*

Materials
XXXXXXXXXXXXXX

trowel

joint compound

door panel

acrylic paints, assorted colors

paintbrushes

sanding block

palette

stencil

matte finish acrylic spray

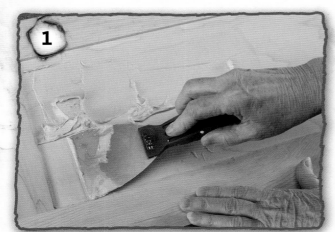

1 Using the trowel, add the joint compound in the recessed area of the door.

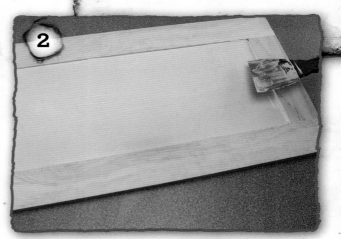

2 Use the trowel to get the joint compound as smooth as possible.

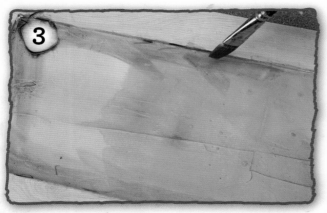

Apply a darker shade of paint around the edges. Let that dry.

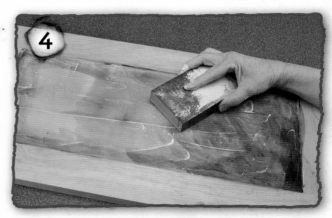

Using the sanding block, lightly sand over the painted plaster.

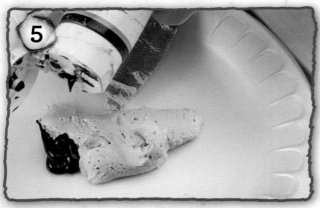

Squeeze some joint compound and desired paints onto a palette.

Use the trowel to mix the colors thoroughly.

Lay the stencil of your choice onto the surface. Use the trowel to apply the colored joint compound across the face of the stencil. Do your best to make this layer an even thickness.

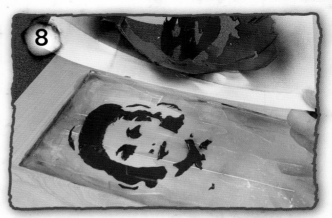

Immediately remove the stencil by lifting it straight up from the surface. Allow the joint compound to dry thoroughly.

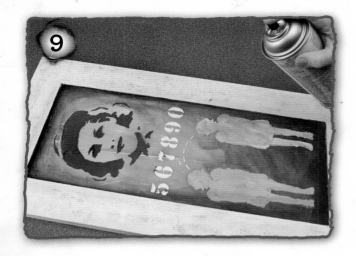

9

Add more stenciled items if desired. These can have paint mixed in or be painted after the joint compound has dried. Embellish the frame as desired. Here I have painted latex paint on the frame and then burned bubbles into the paint with a propane torch while the paint was still wet. After that paint layer dried, I sanded the bubbles and used a matte finish spray to seal the entire piece, including the frame.

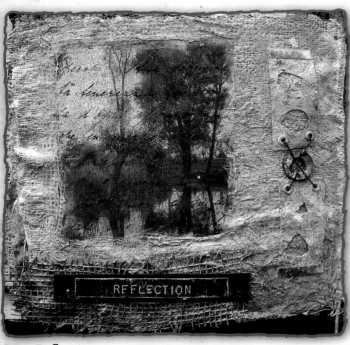

Reflection
Seth Apter

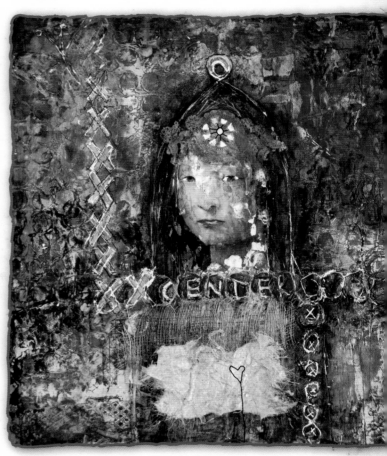

Center
Katie Kendrick

wine angel

This is a technique that I love: adding sparkle to my drawing or painting with a glint of gold foil. While the foil will not adhere to plaster, it loves wax, and on the right piece, it adds dramatically to the overall appearance. It is especially effective on very dark or very pale pieces. Experiment with rubbing a finished piece with a flat baren or piece of cardboard over a large sheet of foil to add sparkle to all the high points of the design.

—*Judy*

Materials

- trowel
- joint compound
- wood panel
- pencil
- transfer paper (optional)
- collage papers
- scissors
- acrylic gel medium
- craft brush
- encaustic medium, craft brush, hot pot
- heat gun
- water-soluble crayons
- Yellow Ochre oil paint or acrylic paint
- acrylic paints, assorted colors
- paintbrushes
- latex gloves (optional)
- paper towel
- metallic transfer foil

Using a trowel, spread joint compound over your board. Let the joint compound dry. Draw the desired image onto the background using a pencil, either freehand or with transfer paper. Cut collage papers as desired.

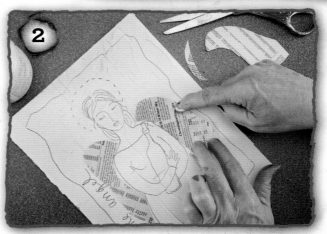

Using gel medium and a craft brush, glue down the papers.

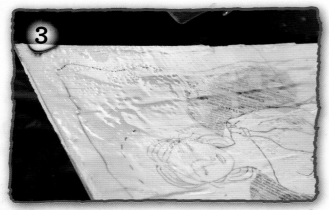

Using the encaustic craft brush, apply hot encaustic medium over the surface. Using the heat gun, fuse the wax to the surface.

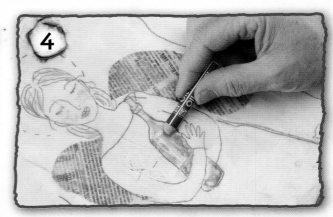

Add color to the surface as desired, using water-soluble crayons.

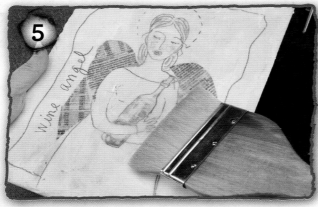

Using the heat gun (gently—do not overheat), heat the surface of the wax to fuse it to the layer beneath it and sink in the color. Then using the encaustic brush, apply a thin layer of encaustic medium over the entire surface.

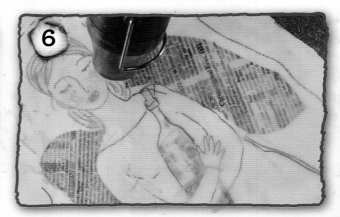

Use the heat gun to fuse the encaustic medium.

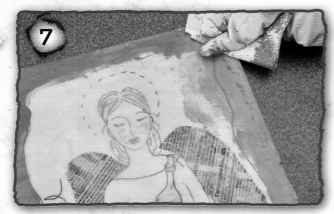

Paint the border with Yellow Ochre oil paint. You can alternately use acrylic paint for this and it will give you a different effect. If you do use oil paint, be sure to protect your hands with latex gloves. Using a flat fold of paper towel, wipe the excess paint from the surface.

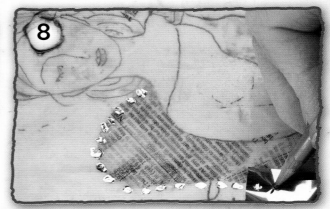

Lay gold transfer foil onto the surface, shiny-side up. Using a pencil or ballpoint pen, draw designs onto the foil. Reposition the foil as needed.

Gauze on Fabric

It's common knowledge that many small things can add up to something big and sturdy. My brother told me about a two-story, open-air building made entirely of scraps from those little wooden 3-D dinosaur and insect puzzles sold at toy stores and truck stops. The result was a massive sturdy structure that seemed, from a distance, to be built of lace with each individual piece being fairly delicate and small.

This project is a variation on that theme. Many small and somewhat delicate pieces of plaster gauze are layered on thin fabric to create a rigid and sturdy substrate rich with texture and depth. You'll have the best results if you try to keep the overall thickness consistent. Areas where more gauze is built up than in others will have a tendency to bow a bit on fabric, but if you use the same technique on a rigid substrate, you won't have that issue. I'm itching to experiment with the same technique of gauze layering on a piece of furniture. Talk about functional art!

—Stephanie

Materials

- muslin or cotton-weight fabric
- acrylic sheet, foam board or cardboard
- plaster gauze
- small tub or pan of water
- acrylic paints, assorted colors (including Burnt Umber)
- paintbrushes, wide and detail
- wet rag
- Stabilo Marks-All pencil
- collage papers
- gel medium
- clear acrylic gesso (Liquitex)

Tear or cut the fabric to the desired size. Dampen the fabric and squeeze out the excess water. Lay the fabric onto a protective, somewhat rigid surface such as acrylic or cardboard.

Tear or cut the plaster gauze into various sizes. (This can get a bit dusty!)

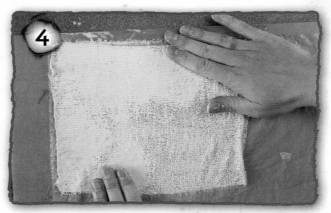

Dip a strip of the plaster gauze into a tub of water. I like to use warm water as it causes the plaster gauze to set up more quickly than if I use cold water. Let the strip drip a bit back into the pan of water without squeezing it out.

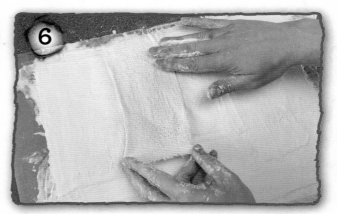

Lay the gauze strips onto the fabric. You can leave a bit of the edge of the fabric showing if desired for more texture.

Use your fingers to rub down the plaster gauze, working the wet plaster into the fabric creating a good bond. As the gauze begins to set, you can rub the gauze to smooth over the texture of the fibers.

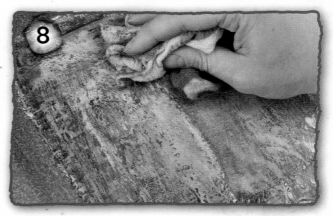

Repeat steps 3–5 to cover the surface as desired. As you smooth the pieces down, pull any obviously loose threads from the edge of the plaster pieces. The edges of the gauze will likely fray and roll a bit. Don't worry about this for now, as long as you smooth out any major bumps or rolls before they harden. Allow the plaster to dry thoroughly.

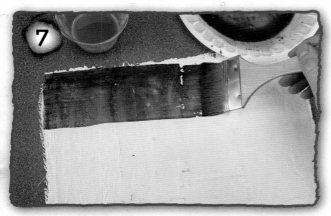

Create a wash with the Burnt Umber paint and water. Using the wide paintbrush, paint the surface of the plaster in small sections.

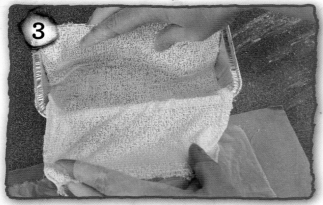

Using a wet rag, wipe the paint in that section. This removes the paint from the high points, leaving it in the low spots and enhancing the texture.

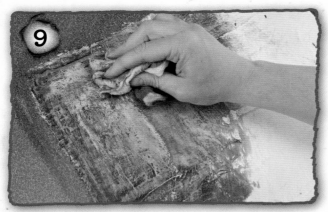

Repeat steps 7–8 to cover the entire surface. Allow the paint to dry.

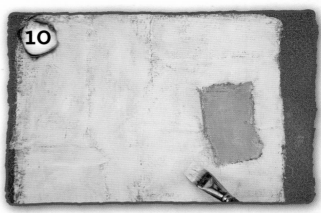

Embellish with paint as desired. Here I added color blocks of paint and then began to fill in the majority of the surface with a thin coat of white paint.

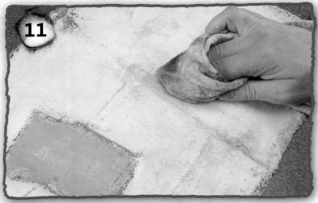

Paint over some of the color blocks with the white paint, using a bit of water to keep the paint from drying too fast if necessary.

Using a damp rag, blend the paint into the surface while also removing a bit from the covered color blocks.

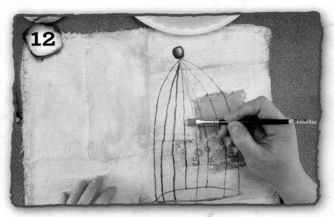

Using the Stabilo Marks-All pencil, draw an image or line drawing. Also, now is a good time to add some collage elements using the gel medium to adhere them. With a filbert or detail brush, go over the pencil lines with a bit of gel medium to blend and adhere the pencil to the surface.

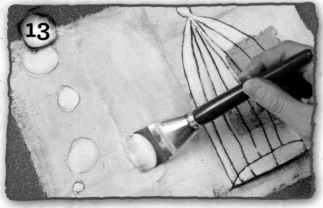

Continue painting as desired, keeping in mind the textural surface of the gauze and working to enhance and preserve it. Using clear gesso or a matte medium, paint over the entire surface to protect it.

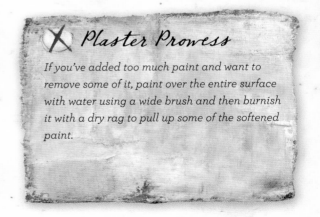

✗ *Plaster Prowess*

If you've added too much paint and want to remove some of it, paint over the entire surface with water using a wide brush and then burnish it with a dry rag to pull up some of the softened paint.

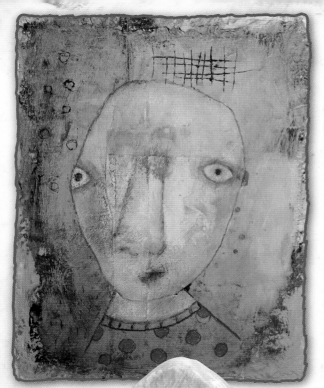

Juliette
Lynne Hoppe

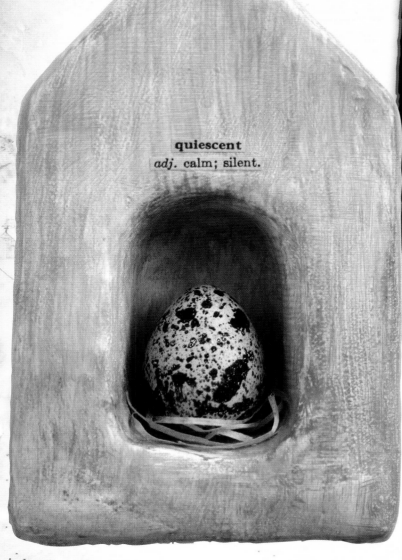

quiescent
adj. calm; silent.

Me, Me, Me, All the Way Home
Heidi Petersen

Quiescent
Stephanie Rubiano

35

Cracked Burlap

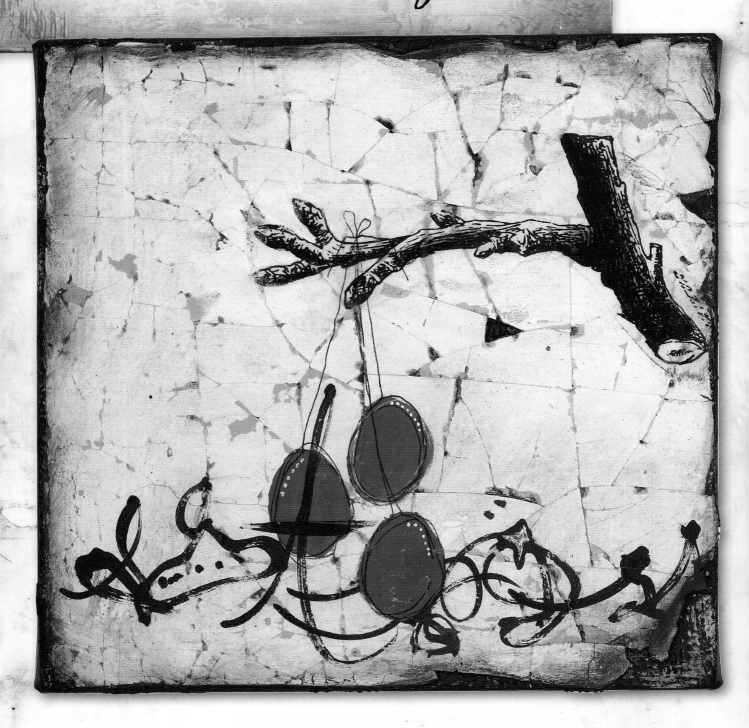

Sometimes I get so focused on figuring out how to achieve a certain effect that I succumb to a type of tunnel vision until I come up with a solution. I stare off into space all too often (at times, for months!), experimenting in my head. I'm smearing plaster in my mind, trying out different substrates to see what might work. Of course, I'm never satisfied until I actually get my hands dirty and can see if my mind-wanderings produce hard evidence.

This technique went through the same process. I'd been hankering to create a cracked, but smooth plaster surface to paint on. I wanted the depth of the cracks to show through the paint. I've experimented on many different kinds of fabrics, and burlap is the only one I've found that works. Its open, hairy weave binds well with the plaster, allowing it to crack without popping off. When it comes to painting on it, I'm usually a less-is-more kind of gal. The cracks put on quite a show without much need for a supporting cast.

—Stephanie

Materials

- plastic bag, such as a garbage bag
- burlap
- substrate, stretched canvas or wood panel
- scissors
- plaster of Paris
- trowel
- rolling pin or brayer
- craft brush (for gluing)
- wood glue
- cutting mat
- utility knife
- sanding block
- butane torch
- acrylic paints, assorted colors (including Burnt Umber)
- paintbrushes
- damp rag
- matte finish spray

1 Lay out a plastic bag. Cut the burlap larger than the size of the substrate.

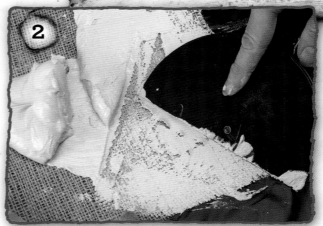

2 Set the substrate aside and lay the burlap on the plastic bag. Mix a batch of plaster according to the manufacturer's instructions. Using the trowel, apply the plaster to the burlap. Press hard with your initial swipe of the trowel to ensure that the plaster is embedded into the burlap well. The burlap will suck the moisture out of the plaster quickly, so work with a soupier mix and a quick stroke.

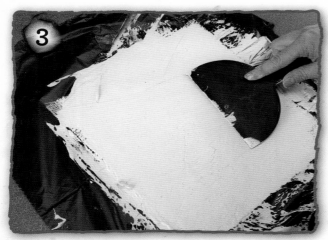

Continue spreading the plaster, building up the layers so the burlap texture doesn't show and smoothing out the surface of the plaster.

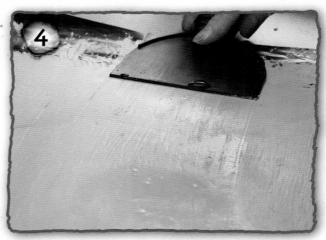

Allow the plaster to set up a bit. The timing of this will vary depending on humidity but should usually take no more than five minutes. It is the right consistency when you can touch it and feel that the plaster is damp, but you are not able to mush it around. Dampen the trowel and use light-pressure sweeps to smooth the surface even more. Let dry thoroughly.

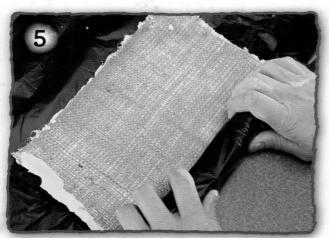

Place the burlap plaster-side down onto the plastic bag. Gently crack the burlap by rolling it up.

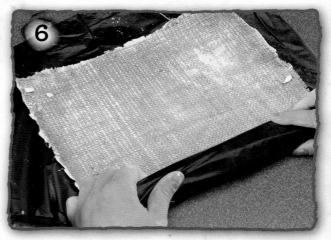

Unroll and then roll the burlap up again in another direction. The fewer times you roll, the larger the cracks will be. You can roll repeatedly in opposite directions to achieve a porcelain or snakeskin effect.

✕ Plaster Prowess

If you feel like the plaster isn't adhering to the burlap well, add about a tablespoon of regular wood glue for every two cups of plaster while mixing. This will create a better bond between the burlap and the plaster.

As an alternative to sandpaper, you can use a Scotch-Brite green scrub pad after painting to create a super smooth surface while bringing the plaster back to white and leaving paint in the cracks.

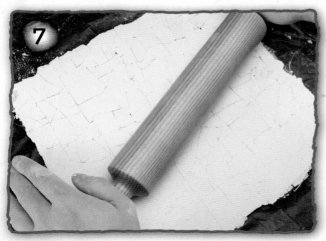

Turn the burlap over and roll over it with the rolling pin or brayer to press any lifted pieces of plaster back down.

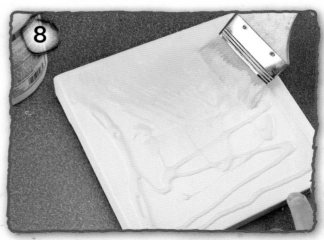

Using a large craft brush, generously apply wood glue to the entire surface of the substrate. Make sure to get right up to the edges of the substrate because that's where it's likely to pull off.

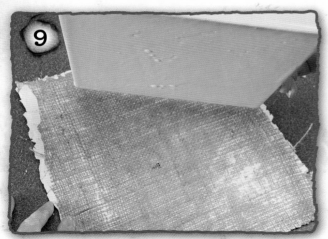

Flip the burlap over. Press the substrate glue-side down onto the burlap.

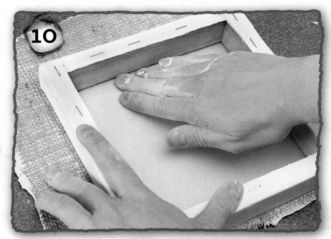

Press the substrate firmly onto the burlap. Allow the glue to dry thoroughly facedown. Weight it down with something heavy if necessary.

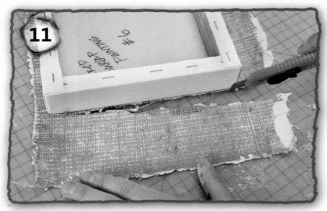

Place the burlap-covered substrate on the cutting mat. Using a utility knife, trim the excess burlap from the substrate. You may need to make a few passes with the cutter to cut through.

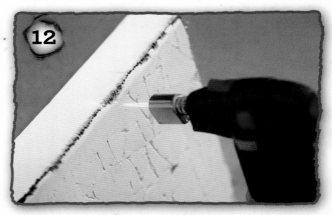

Sand the edges of the cut burlap. This will reveal some of the burlap fibers more. Using the butane torch, burn off the loose fibers. Repeat the sanding and burning as needed to eliminate the excess fibers.

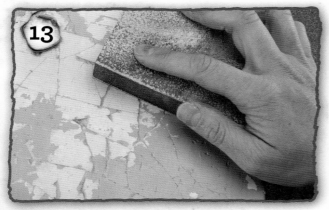

Paint a thick layer of paint over the entire surface. Use the paintbrush to work the paint into the cracks. Add a bit of water to the surface if necessary to help. Sand the surface, leaving the paint in the cracks. You can do this immediately or wait for the paint to dry. Use a damp rag to wipe the dust off the surface.

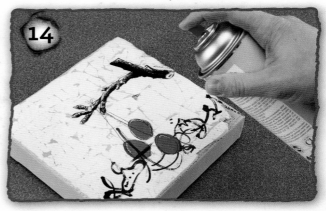

Continue painting on the surface as desired. Because of the texture of the cracks, very little embellishment is needed for visual interest. Spray with a coat of matte finish spray.

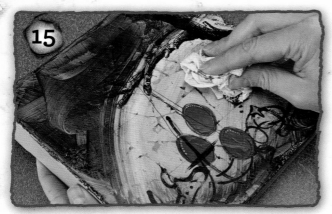

Slightly water down some Burnt Umber paint and coat the entire surface. Immediately wipe off with a damp rag, leaving more paint around the edges.

Transfers

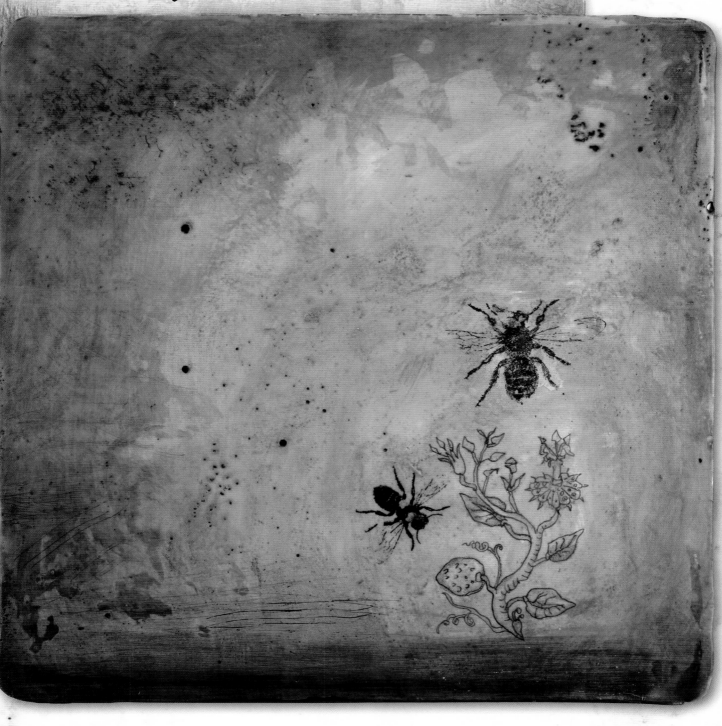

In this project we'll show you how to pour a raised plaster of Paris surface onto a cradled or flat board, how to construct a strong hanger to support the weight of the plaster and how to transfer a toner copy directly onto the plaster surface. But wait, there's more! After we paint the plaster, we'll wax, fuse, do a second toner copy transfer onto the wax and fuse again to lock all the layers firmly into place.

—*Judy*

Materials

- wood panel, flat or cradled
- pencil
- drill and ¹⁄₁₆" (2mm) drill bit
- rebar wire
- masking tape
- spoon (for burnishing)
- plaster of Paris (including mixing container and paint stirrer)
- trowel
- images to transfer (printed from a laser/toner-based copy machine)
- cotton swab
- citrus solvent (Citrasolve)
- acrylic paints, assorted colors
- paintbrushes
- acrylic gel medium
- encaustic medium, craft brush, hot pot
- heat gun
- soft cloth (optional)

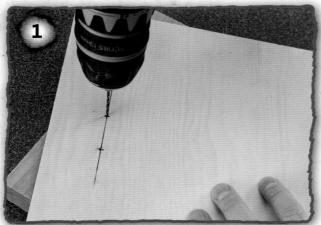

Decide where you want the wire to go, on the back of the wood panel, and measure and mark for two holes, approximately 1½" (4cm) apart. Drill a hole at each mark.

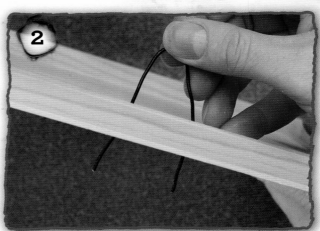

Bend the rebar wire in half and push the two legs through the holes from the back to the front. Leave enough of a V on the back to act as a hanger.

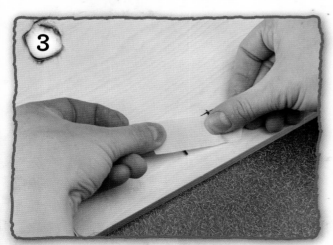

Bend the rebar legs flush to the front of the board. Use masking tape to secure them to the front.

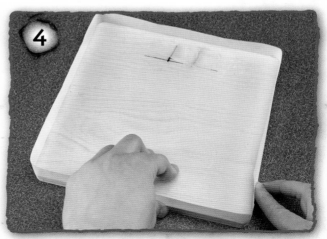

Use the masking tape to create a well around the perimeter of the board. Burnish the tape well so none of the plaster can seep through.

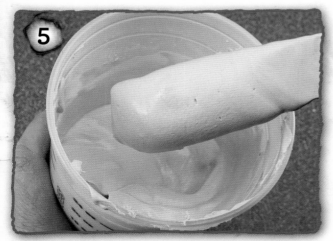

Mix the plaster. For this project, you want it the consistency of whipped frosting. Add more powder or water as needed to achieve this result.

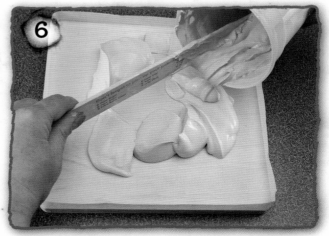

Using the stick to help get the plaster out of the mixing container, pour the plaster over the surface of the board.

Smooth the plaster out, making sure to get it into the corners.

Tap the mold onto the table to level the surface. Allow it to dry.

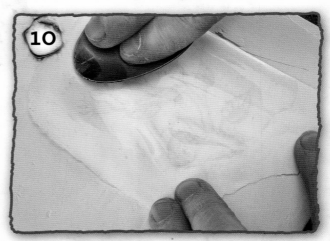

Remove the tape from the frame. Using the trowel, scrape the edges to clean them up.

Place the toner copy facedown on the plaster. With a cotton swab, apply citrus solvent to the back of the transfer, alternating burnishing with a spoon and adding more solvent. Use sufficient pressure and check the transfer results before removing the copy. You should get a sharp, dark transfer.

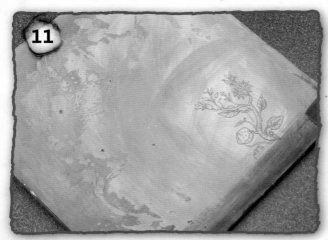

Paint and embellish the board as desired, using a gel medium primary layer (applied with loose, flip-flop strokes and leaving lots of plaster uncovered) to resist the overlying washes of acrylic paint. Let that layer dry before adding the color layer. This will give your piece added depth.

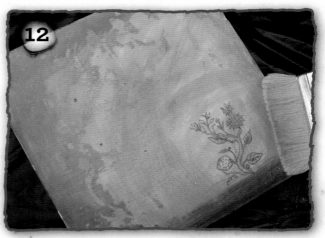

Using the paintbrush, brush the encaustic medium over the surface.

Using the heat gun, even out and fuse the wax to the painted surface.

Add another toner copy transfer, this time to the surface of the wax. Place the copy image-side down and burnish well. Then add water gradually, burnishing slowly and carefully while adding more water until the paper begins to disintegrate.

After the medium is dry, roll away any remaining paper fibers with light pressure and your fingertip. Remember that once the paper rolls away, the toner layer is fragile and too much pressure will dislodge it.

Use the heat gun to fuse the image to the wax. Now the image is stable.

Using the palm of your hand, polish the wax to buff it to a shine. If your hands are too moist to bring up a shine, use a soft cloth and rub briskly.

Sandi
Judy Wise

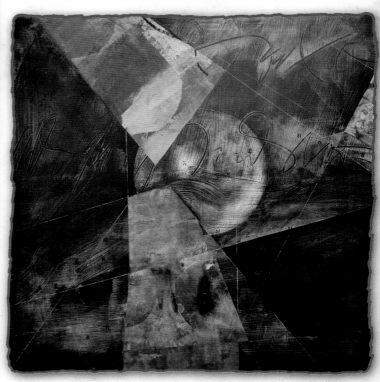

Navigation 2: Meandering
Jill Berry

Watercolor & Graphite

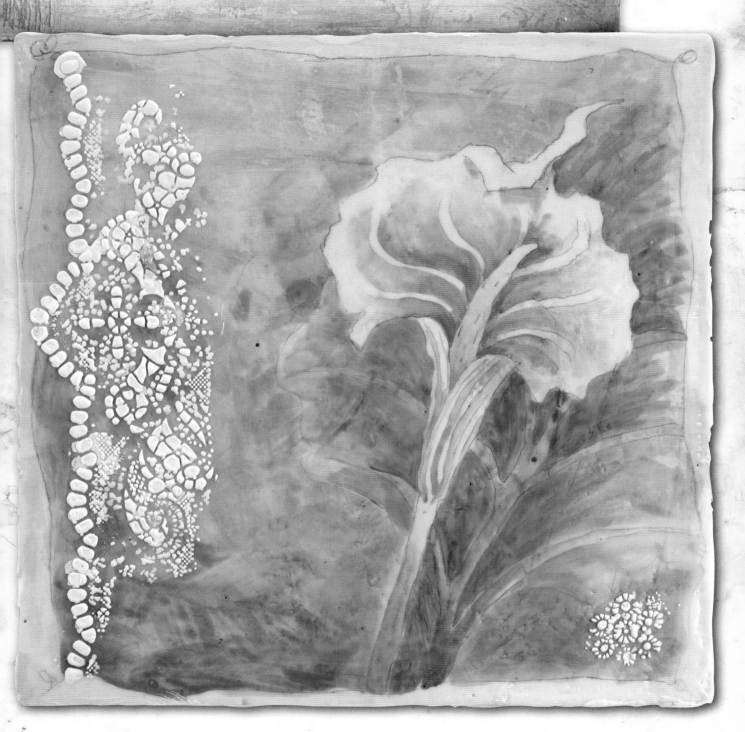

I have to say that this is one of my favorite ways to approach plaster as I love pencil drawings. Most of us have memories of drawing in pencil as children, and while graphite was often our first drawing medium, it is still the favored tool for many artists due to its sensitivity and range of effects. On plaster, graphite can be smudged and worked to great advantage. In addition, if you don't like the drawing (or the painting for that matter), you can scrape off the top layer of plaster and begin again.

—Judy

Materials

wood panel, flat or cradled

graphite pencil

rebar wire

drill and 1⁄16" (2mm) drill bit

masking tape

plaster of Paris (including mixing container and paint stirrer)

trowel

acrylic paints, assorted colors

paintbrushes

encaustic medium, craft brushes, hot pot

heat gun

white oil paint

hot plate

stencil

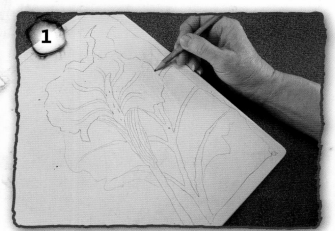

Prepare a panel by using the poured plaster method used for steps 1–12 in the Transfers painting, pages 42–45. Now use a graphite pencil to sketch out your composition.

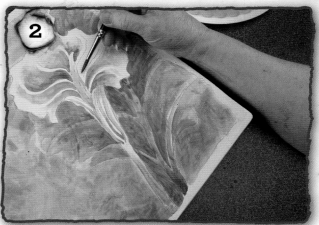

Using thinned acrylic paints, paint the surface as desired. You'll see that the plaster absorbs the paint rapidly, giving it the effect of watercolor. Of course, you can actually use watercolor, too, if you prefer or if you have them on hand. Allow the paints to dry.

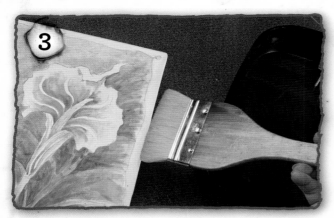

Using a craft brush, coat the painting with a layer of encaustic medium.

Use a heat gun to fuse the wax to the surface.

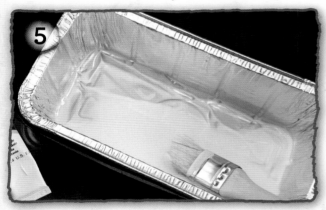

Add a bit of white oil paint to a smaller amount of wax. You can do this on a hot plate or in a small container set on a coffee warmer.

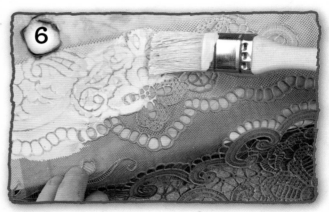

Working with a smaller craft brush (I used a chip brush from the hardware store), apply the white wax over the stencil (here I am using a piece of plastic tablecloth) and onto the surface of the painting.

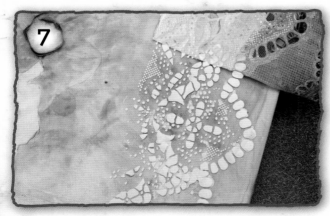

While the wax is still warm, gently pull the stencil off of the surface. Repeat in additional spots on the painting as desired.

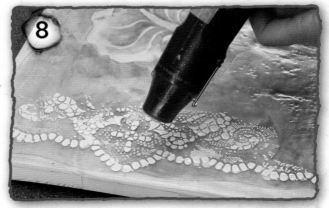

Using the heat gun, gently fuse the white wax, being careful not to over-melt the delicate parts.

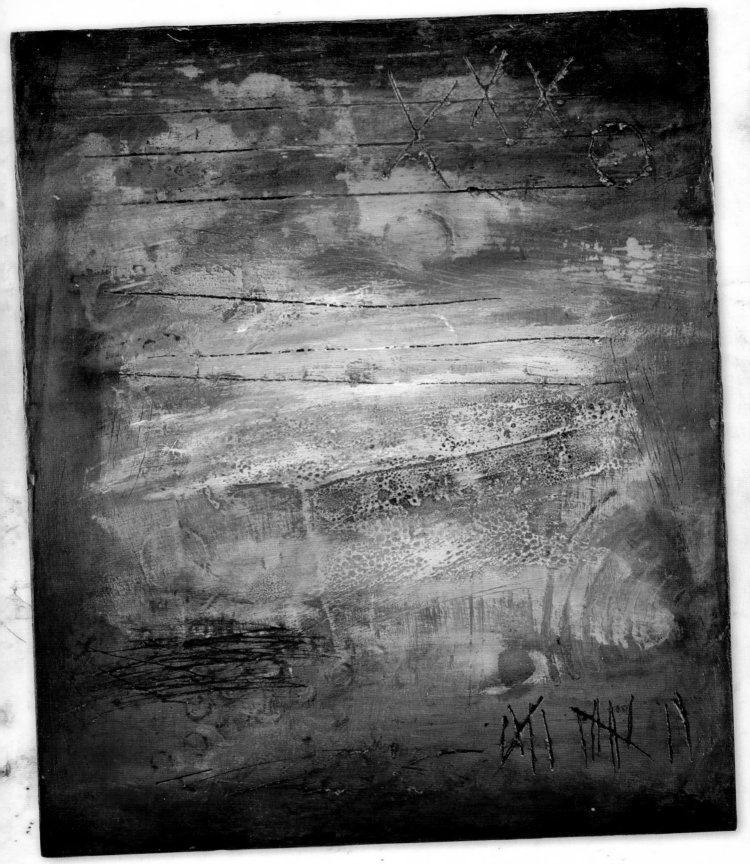

Casting and Carving

Plaster castings have been used for ornamentation on European architecture for centuries. The desire to enhance our surroundings with ornamentation is age-old, and the projects in this chapter explore the options between subtractive and additive approaches.

When working from a subtractive approach, the idea is to remove material to achieve a desired effect, and, of course, an additive approach means to add or build up material to achieve the results one is after.

Subtractive work can be done with various tools including wood carving tools, wire brushes and even masking off areas that will be left void of plaster after the plaster is spread on the substrate. When plaster is wet and malleable, you can remove parts of it by drawing into it with a tool (the closest dull pencil on hand works great) or by lifting plaster away with a palette knife or trowel. Once the plaster has begun to harden, you'll need to use tools that are a bit stronger. Wood-carving tools are ideal for scraping away hardened areas in bas-relief.

Additive work can be done in a variety of ways. Adding texture and depth with gauze and subsequent layers of plaster is the obvious choice, but you can also duplicate three-dimensional objects through casting. A variety of molding options are available on the market, and in this chapter we explore the simple use of polymer clay to act as our mold. Because the clay is so soft and smooth, an extreme amount of detail can be captured from the found objects being cast. These castings can be blended in with spread or poured plaster to appear as though they are actually carved, in depth, from the plaster on the substrate.

Let's dive into the exploration of creating depth!

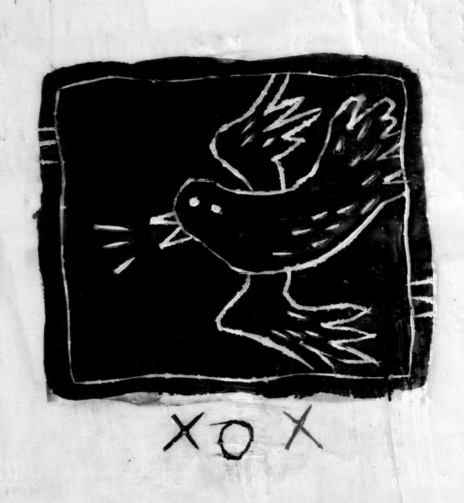

Call it what you like: sgrafito, graffiti, reductive or subtractive. Since the days of living in caves, artists have amused themselves by scratching into trees, rocks and walls to express themselves. Plaster is the perfect material for this kind of play; the soft surface nearly begs for a sharp tool and a layer or two of soft color. In addition to revealing underlying color, you can change the look further by filling in the scratched-out areas with color. Let your mind sail away with all the possibilities and see what your experiments produce.

—Judy

Materials

XXXXXXXXXXXXXXXX

plaster of Paris

trowel

wood panel

acrylic paints, assorted colors (including black)

acrylic gel medium

paintbrush

carving tool

tissue or soft paper towel

encaustic medium, craft brush, hot pot

heat gun

Mix up some plaster, and using a trowel, apply a thin coat onto the panel.

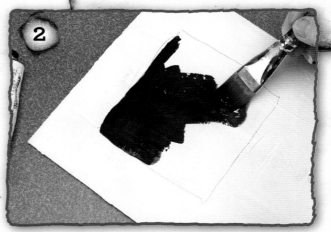

Paint an area of the plaster black with black watered-down paint.

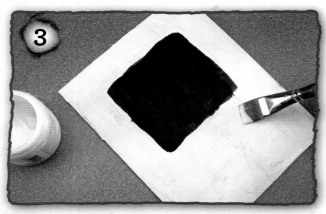

3

Paint gel medium over the rest of the plaster. Allow the gel medium and paint to dry.

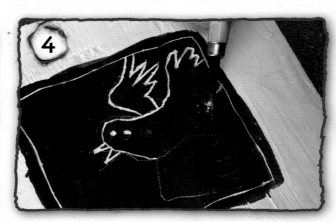

4

Carve your design into the plaster using a carving tool.

5

Use your fingers to press paint into the carvings, and then use a tissue to wipe the excess paint from the surface.

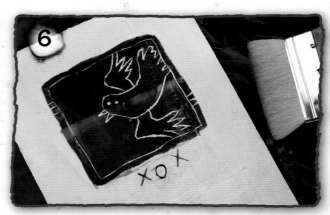

6

Using the craft brush, apply hot encaustic medium over the entire surface.

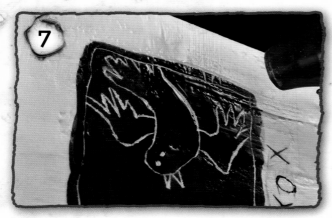

7

With a heat gun, fuse the wax to the painted surface.

✗ *Plaster Prowess*

If paint remains on the gel medium surface, you can use a cotton swab dipped in rubbing alcohol to remove it.

Shallow Carving

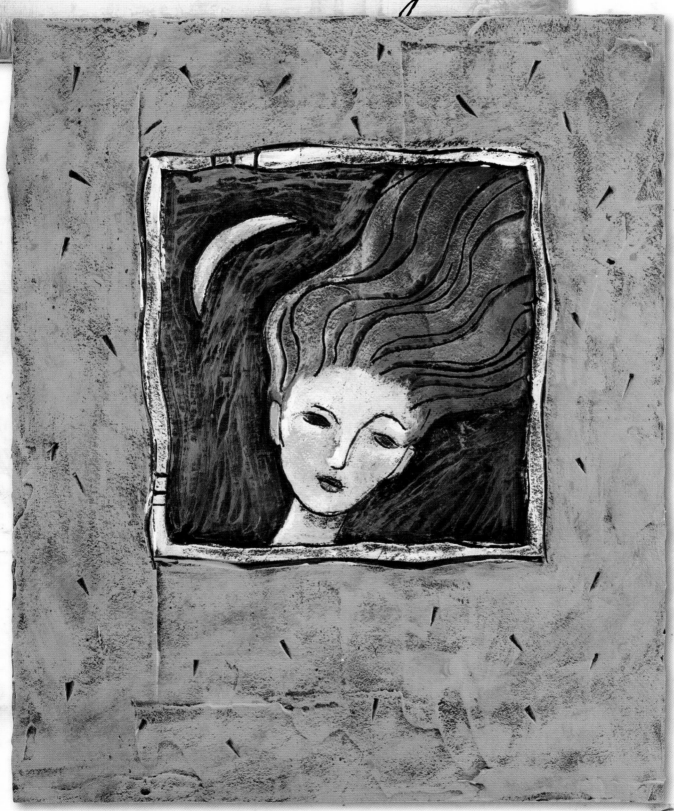

Making dimensional paintings in plaster is both easy and fun. The joint compound is a breeze to scribe and carve into, and the effects you can achieve by painting over a toned background are dramatic. In the following demonstration I'll show you how to make a simple carved drawing. Joint compound is the preferred material for this technique as it is more porous and easier to carve than plaster of Paris. I've used this technique to make book covers too, and it is one of my favorites.

—Judy

Materials

XXXXXXXXXXXXXXX

trowel

joint compound

wood panel

carving tools

paintbrushes

chalk pastel

acrylic paints, assorted colors

1

Using a trowel, spread the joint compound onto the wood panel. Allow it to dry.

2

Using a pointed carving tool, scribe the drawing or desired design into the surface.

Remove the dust from the surface with a soft brush and lightly rub a chalk pastel over the areas to be carved. This will help you see your progress better. Carve away the plaster from around the scribed lines. You may choose to round some of the forms for a deeper bas-relief.

Keep carving until you are satisfied with your design. Make a fairly opaque color wash and gently paint it over the desired portions of the surface. Be careful not to overwork the joint compound or it will dissolve and muddy the paint. Allow the paint to dry.

Continue painting as desired.

Four Moments of the Sun
Patricia Wheeler

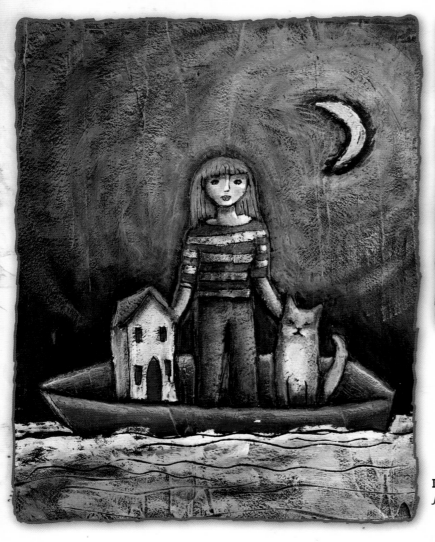

Drift
Judy Wise

Excavation Painting

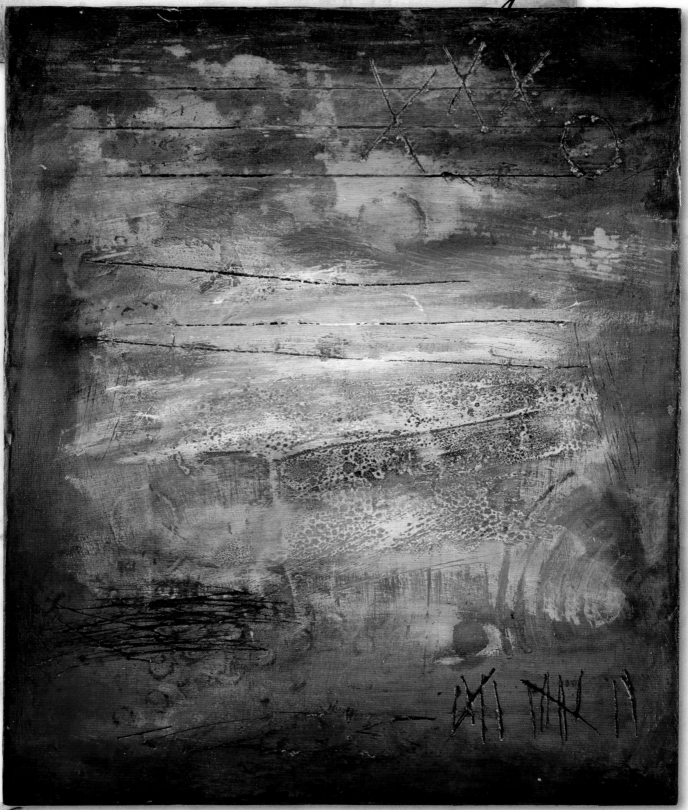

Certainly deconstruction is nothing new, but the immediacy of results and the ease in which the layers of joint compound can be worn through make this project especially inviting. I suggest working on braced wooden panels for really large work, but I have also done this technique on materials as thin as heavy watercolor paper. The joint compound has just enough give to keep the material from popping off the paper substrate if the layer is fairly thin. This is also a wonderful way to make book covers, using thin birch plywood as a base. Your lumberyard will cut plywood to size.

—Judy

Materials

XXXXXXXXXXXXX

- trowel
- joint compound
- wood panel
- wide-tooth comb
- bubble wrap
- lid from a glue stick or small bottle
- acrylic paints, assorted colors
- paintbrushes, wide flats
- clay-carving tools (optional)
- sanding block
- wide brush
- steel brush
- white latex wall paint
- propane or butane torch
- acrylic gel medium
- tissue or paper towel
- satin gel medium or cold wax (Dorland's)

1 Using a trowel, spread a layer of joint compound onto the wood panel.

2 Let the joint compound dry for 1–2 minutes. Drag a wide-tooth comb through the joint compound.

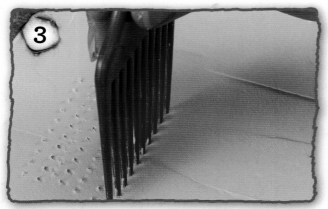

Also use the comb to create rows of dots by pressing the comb into the compound.

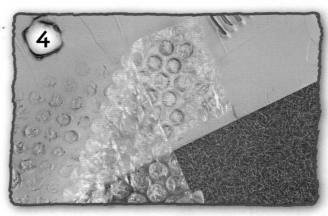

Press bubble wrap into the joint compound to add some texture.

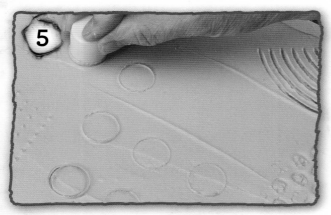

Use a glue stick lid to create circles.

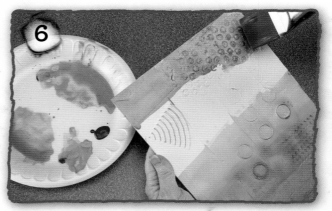

Make a color wash with desired acrylic paints and water. It should be the consistency of skim milk. Using a wide brush, gently apply the wash to the surface going only in one direction. Flow the paint on easily. Don't overwork it or it will break up the joint compound. Allow the paint to dry.

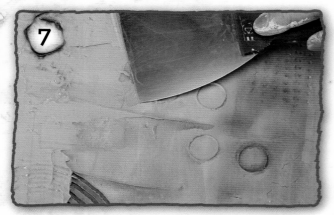

Using the trowel, apply another thin layer of joint compound to the surface. Allow the compound to dry.

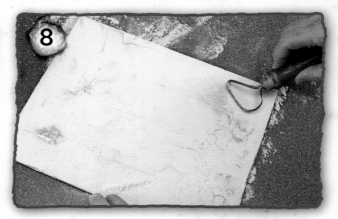

Using the clay-carving tool or a sanding block, carve through the last layer of joint compound to reveal the colors underneath.

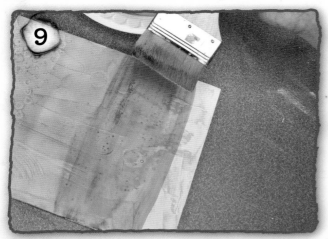

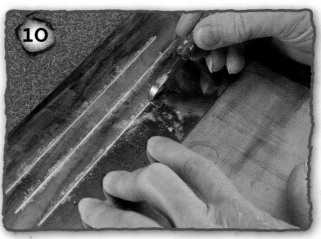

Brush any dust off the surface. When you've achieved the look you like, add another color wash (skim milk consistency) to the surface. Allow the paint to dry.

Use the carving tool to freehand draw some designs as well.

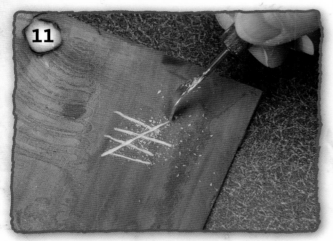

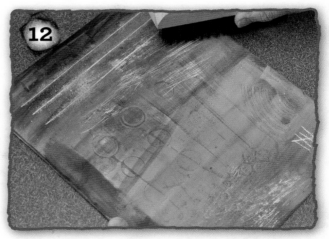

Do this in a few areas on the painting.

Use a steel brush to texture the surface, and then remove all the plaster dust.

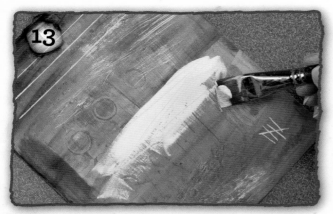

Using a paintbrush, apply a thick layer of latex paint to the surface. Go on to the next step while the paint is still wet.

Use a butane or preferably a propane torch to blister the paint surface. (Do this with safe ventilation.) Allow the paint to cool and dry. The butane will make small bubbles, and the propane torch will make larger ones. I like the larger ones, depending on the size of the piece.

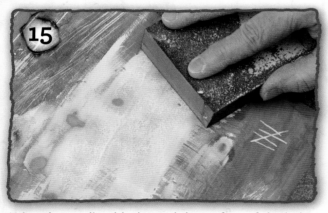

Using the sanding block, sand the surface of the bubbled paint.

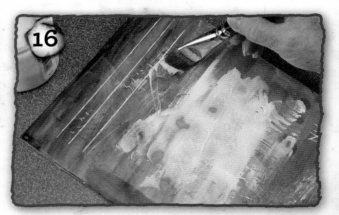

After you've distressed the plaster as much as you like, apply a layer of gel medium over the entire surface. Allow the gel medium to dry.

Sand the edges.

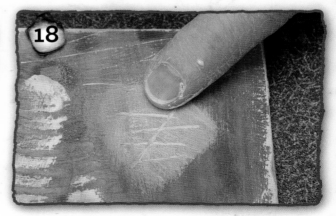

Using the desired colors of acrylic paint, rub paint into the crevices with your fingers.

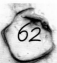

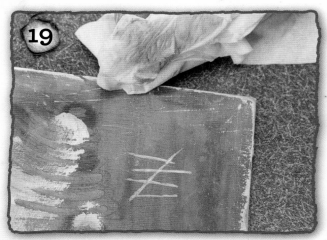

Use the tissue to wipe the excess paint from the surface of the crevices. Be sure the crevices are deep enough to hold paint.

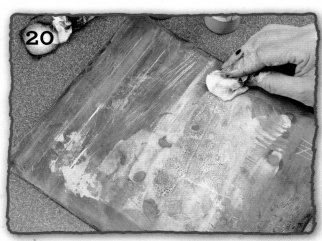

Continue to rub contrasting and bright glaze colors of paint into the carved and scratched areas that you have created. As you color each area, use the tissue to wipe the excess paint from the surface, leaving the paint in the deeper areas. Continue to work the surface in this way until it satisfies you.

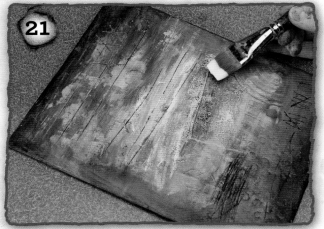

Using satin gel medium (mix matte and glossy—half and half) or Dorland's cold wax, paint or rub a layer over the entire surface to seal the artwork. Allow it to dry.

Plaster Prowess

Different fuel will give you different effects. Butane will make the surface bubble, but propane will create larger bubbles, causing large areas to blow out.

Cast-Object Frame

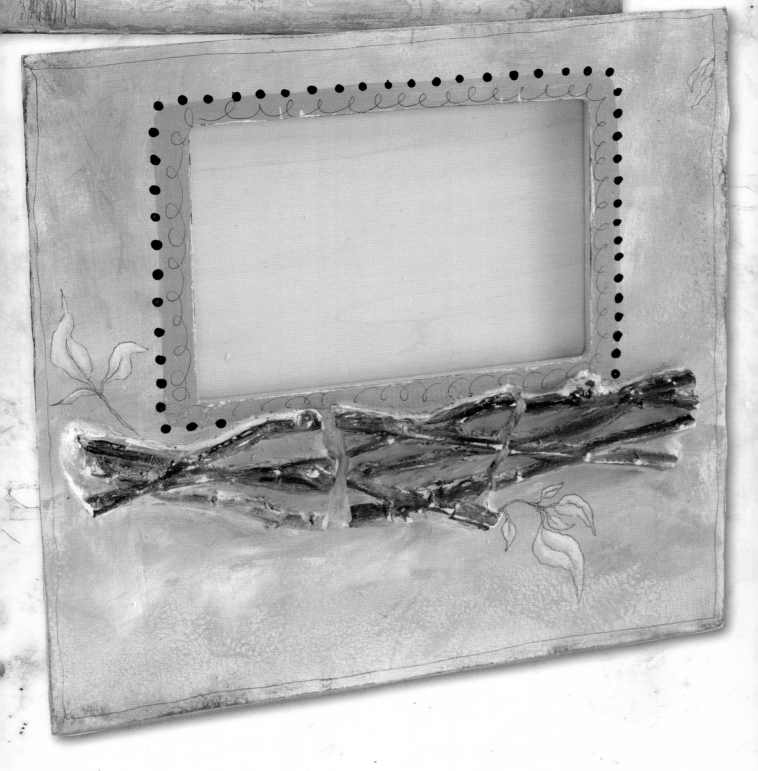

At the turn of the century, cast plaster ornamentation was used to add architectural interest on walls and ceilings of homes and public buildings. Large, ornate frames that were previously carved in wood were now able to be produced more quickly through the use of plaster casting. Even today, you can find intricately detailed frames made using this technique, and here I show you how to make your own.

You can lean toward the traditional by repeating a casting on the face of a regularly proportioned frame, or do what I've done and use a more modern frame with irregular castings applied as part of the focus.

—Stephanie

Materials

- flat photo or mirror frame
- acrylic paints, assorted colors
- paintbrushes, including a wide craft brush
- wood blocks
- butane torch
- polymer clay (Sculpey)
- shallow found objects to cast (I used sticks)
- plaster of Paris
- craft knife
- two-part epoxy (I like 5-minute set)
- joint compound (small amount)
- sandpaper
- spray matte varnish

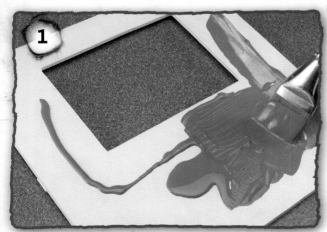

1 Remove the glass and backing from the frame. Paint the frame with a thick coat of acrylic paint.

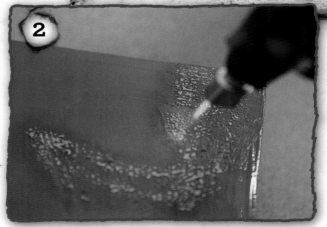

2 While the paint is still somewhat wet, take the frame to a well-ventilated area and set it on a few wood blocks to raise it from your work surface. Burn the paint with the butane torch to create bubbles and toasted paint. Allow the paint to cool and dry thoroughly. Repeat steps 1–2 with as many colors and coats of paint as desired. I finished this piece with a coat of white paint, after burning the blue layer you see here.

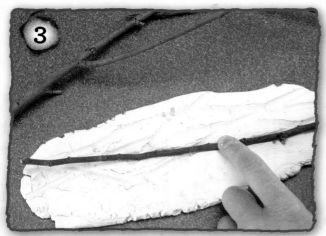

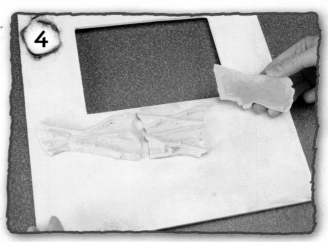

Create a mold for your found objects by rolling out the clay. Press the objects into the clay and then carefully remove them. Lift your slab of clay to make sure it's not stuck to your work surface. Mix and pour plaster into the mold. Allow to dry thoroughly and then pop it out of the mold. Use a craft knife to neaten the edges of the plaster pieces. I broke mine for interest.

Mix the two-part epoxy according to the manufacturer's instructions. Use this to adhere the plaster pieces to the front of the frame where desired.

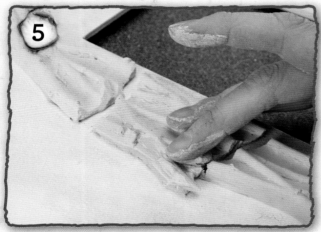

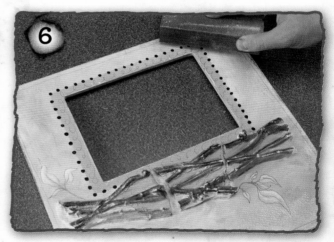

Once the epoxy has dried, use joint compound to fill in any gaps between the plaster pieces and the frame for a more cohesive look.

Paint the frame as desired to blend the cast pieces with the frame. Sand for textural interest. Spray with a matte varnish to seal it.

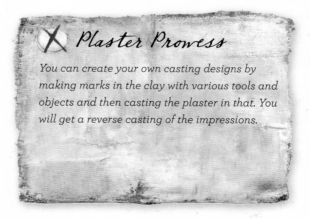

✗ Plaster Prowess

You can create your own casting designs by making marks in the clay with various tools and objects and then casting the plaster in that. You will get a reverse casting of the impressions.

Cast-Object Assemblage

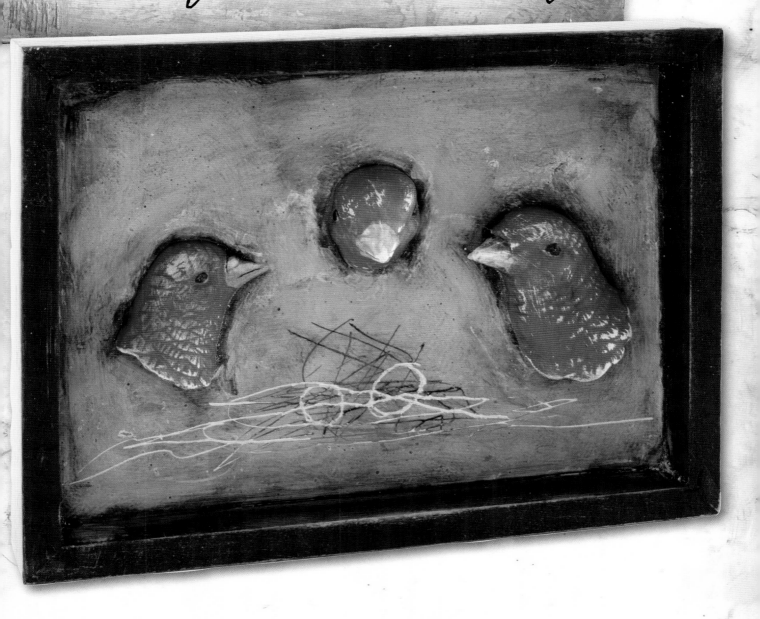

One of my favorite things to do with plaster of Paris is to reproduce objects that are one-of-a-kind or that I want to create duplicates of. Here I've taken a thrift shop bird figurine with simple detail and cast it from three different angles. The Sculpey clay is firm enough to hold the shape of the object, smooth enough to capture intricate detail and dry enough not to stick to the object itself. Also, because it is the oven-dry variety, it will stay flexible while the plaster is hardening in open air.

I've cast so many different things and am amazed at how perfect the tiniest, most intricate details are captured in the casting as long as the clay mold is prepared properly. The only downside to this technique is the desire to carry a wad of clay around with me all the time in case I come across anything I might want an impression of.

—*Stephanie*

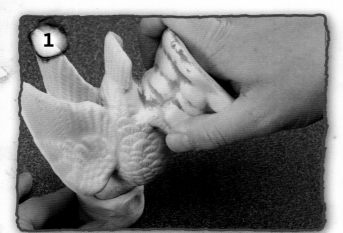

Soften a lump of clay and create a ball similar to the size of the object you are going to cast. Push the clay onto the object. With the object still in the clay, press the bottom of the clay onto a flat surface to create a bottom so the mold will stand on its own.

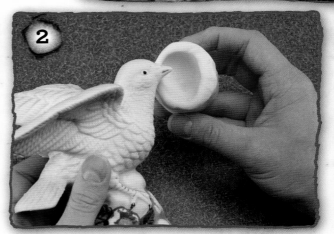

Gently remove the clay off the object being careful not to distort the shape.

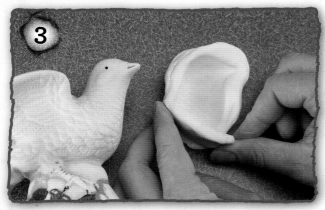

Create multiple castings of the object from different angles using additional balls of clay. When removing the clay, if you find that there are low spots where the plaster could leak out, create a little clay dam to block those openings.

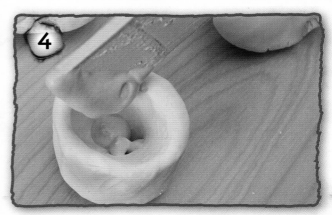

Mix some plaster to about the same consistency of stiff egg whites. Fill the deepest parts of the mold with plaster.

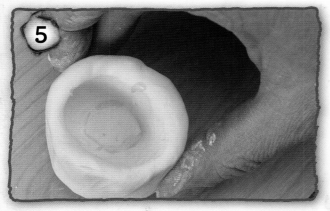

Gently tap the mold on the table to lift any air bubbles and to settle the plaster in the low spots.

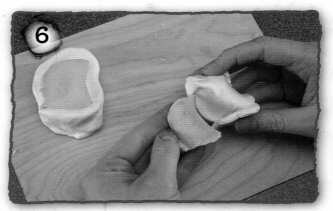

Continue to fill the molds with plaster, tapping as needed. Allow the plaster to set up thoroughly. Gently remove the castings from the clay.

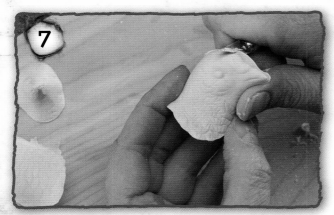

Using a craft knife, gently scrape the edges of the castings to clean them up a bit.

Remove the glass from the frame. Reinsert the panel backing and turn the frame over. Tape around the perimeter so the plaster won't leak out. This will act as a box to contain the poured plaster which you will add later.

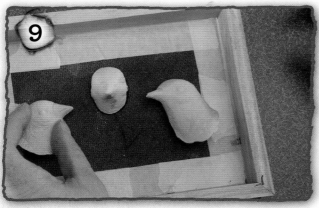

Arrange the castings in the frame as desired and glue them down with the two-part epoxy. Let the glue cure thoroughly.

Mix some plaster and scoop it into the frame around the castings.

Tap the frame on the table to release air bubbles and to settle the plaster evenly into the corners.

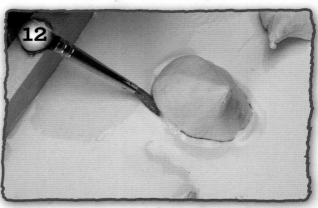

If needed, use a small, wet paintbrush to touch up and blend the edges around the cast plaster pieces. Allow the plaster to dry.

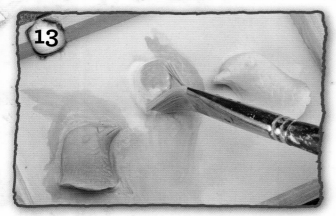

Using watered-down acrylic paint, add a wash over all the plaster, including the cast pieces.

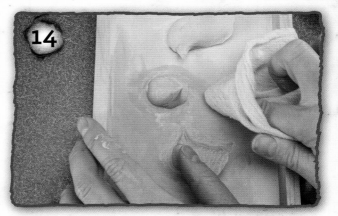

Immediately wipe with a damp rag to even out and blend the paint.

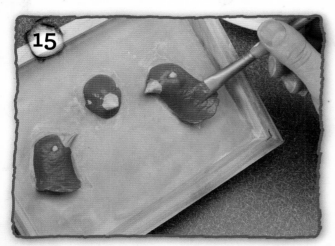

Using a small paintbrush, paint the castings a contrasting color, adding detail where desired. Let dry thoroughly.

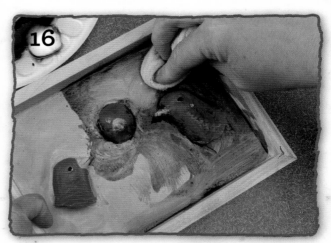

Add details to the castings as desired. Apply a less watery wash of Burnt Umber paint and immediately wipe off with a damp rag, leaving some of the Burnt Umber paint in the low areas.

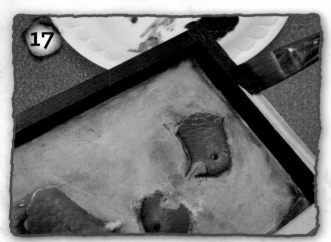

Paint the frame with a contrasting color. Here I used more Burnt Umber.

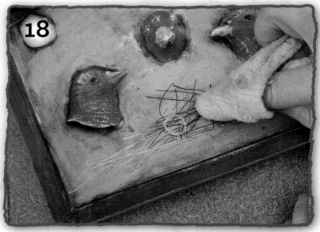

If desired, scratch into the plaster to create interest. Paint over the scratches and wipe off the excess with a damp rag, leaving paint in the crevices.

✗ Plaster Prowess

You could use a cradled wood art panel or wooden craft box instead of a frame. In fact, anything that will contain the poured plaster will work great!

Stenciled Plaster

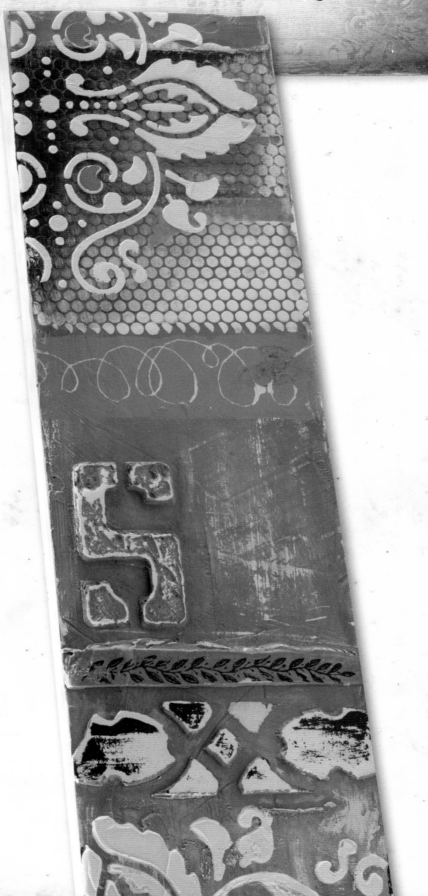

Wood makes a fantastic substrate for both plaster of Paris and joint compound. The key is to not use a milled lumber plank because when it's coated on one side with a wet medium, it will cup and bend. Often you don't realize this has happened until your plaster is cured and you are ready to paint. Or worse— you're done painting and it all pops off in a sheet of unsupported plaster. Trust me.

To prevent this from happening, use a cradled wood panel or plywood. This is the perfect technique to use rough, inexpensive plywood as it actually has more tooth than the smoother, more expensive type.

You also can use joint compound with this technique. You'll just want to allow more drying time between each layer of stenciled compound to allow it to harden. You can paint the whole thing at the end or apply paint between the layers of stenciled compound. Yet another technique that can be taken in a million different directions!

— *Stephanie*

Materials

- plaster of Paris (including mixing cup and stir stick)
- trowel
- plywood, wood panel or similar substrate
- sanding block
- damp rag
- variety of stencils (paper or acetate)
- acrylic paints, assorted colors
- paintbrushes, including a 2" (5cm) flat brush
- matte finish spray

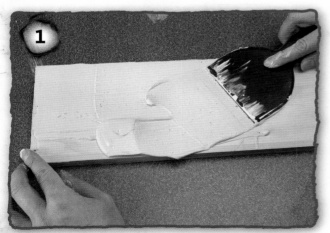

Mix the plaster of Paris to about the consistency of cake frosting. Using your trowel, spread it evenly on the substrate until it is covered. Let the plaster set for about an hour or more.

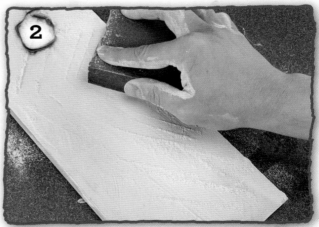

Sand the surface of the plaster with the sanding block to smooth it down a bit.

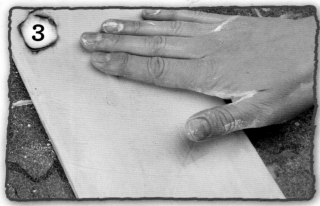

Remove the dust with a damp rag. Moisten the surface of the plaster with water a couple of times using your hand. Do this until you start to get a little bit of shine on the surface from the water that won't absorb. Let it sit for a minute just so it's not slippery wet.

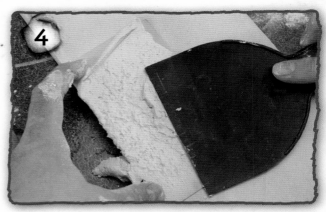

Lay a stencil on the set plaster where you would like the pattern to be. Spread more plaster over the stencil in a thick coat using the trowel.

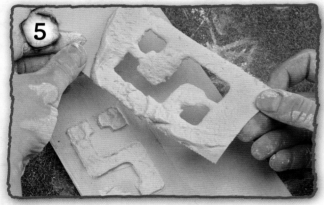

Carefully lift the stencil right away and check the pattern to see if you like it. If not, you can immediately wipe off the plaster with a damp rag or paper towel and redo it.

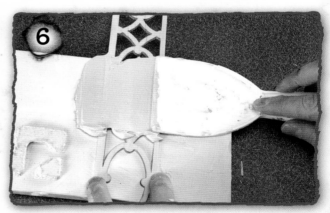

Lay another stencil elsewhere on the panel and add more plaster.

Lift the stencil and repeat step 5. Do this as many times as you want with as many stencil patterns as you want. Feel free to layer stencils on top of stencils with a light sanding between layers.

Let the entire piece sit until cured—overnight or longer. Paint as desired and then sand some of the high points of the stencil patterns to reveal the white of the plaster. Wipe off any dust with a slightly damp rag. Let dry again and seal the piece with a couple coats of matte or satin spray sealer.

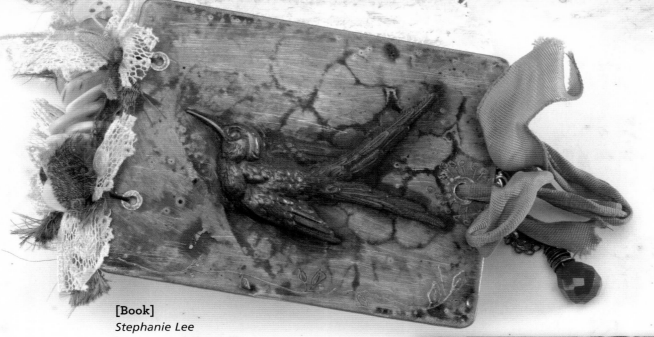

[Book]
Stephanie Lee

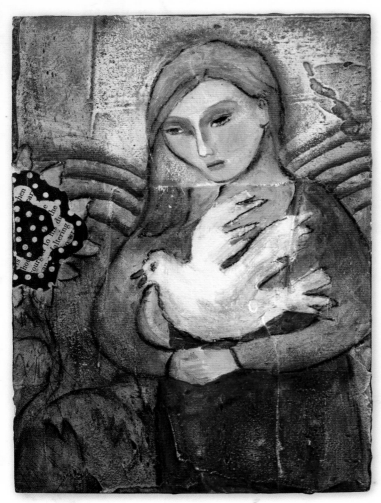

Messenger
Judy Wise

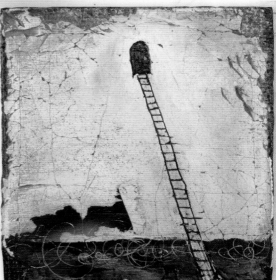

Stairway to Heaven
Stephanie Lee

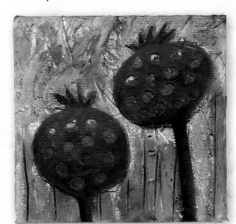

Poppies
Ro Bruhn

Grid Form

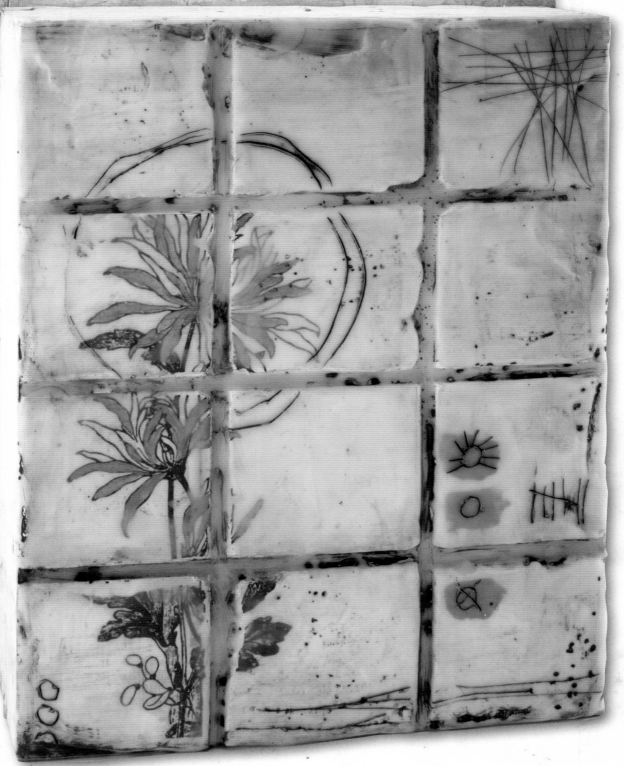

A few years ago I was experimenting with different surface techniques and taped out a wood panel with some leftover ¼" (6mm) florist tape I had lying around. When I peeled up the tape, I loved the depth of the texture but didn't so much love the uniformity of the grid pattern. It sat in my studio for at least a year until I was leaving to go to an encaustic class and decided, at the last minute, to throw it in my stack of substrates that we were asked to bring.

Once I applied paint and encaustic medium, it ended up being my favorite piece from the class and, incidentally, was also the instructor's favorite, and she took it home with her—in trade, of course.

This technique creates so much depth and interest, and the voluptuousness of the encaustic medium balances out the straight lines and hard edges. It almost appears to be a field of stone tiles centuries old and covered in layers and layers of time.

—*Stephanie*

Materials

- wood box or cradled panel
- masking tape, ¼" (6mm) width
- plaster of Paris
- trowel
- sandpaper
- acrylic paint, assorted colors (including Burnt Umber)
- paintbrushes
- encaustic medium, craft brush, hot pot
- heat gun
- carving tool
- damp rag
- dry rag

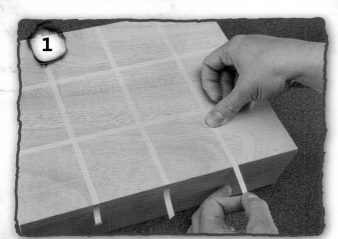

Make a grid pattern with the masking tape. Leave tails of the tape hanging over the edges so you'll have something to pull on later. Be sure to burnish the tape down well to the panel.

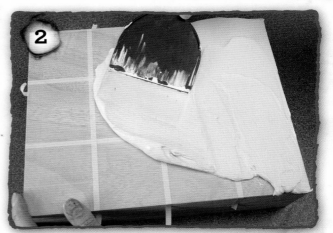

Mix the plaster to about the consistency of cake frosting. Using your trowel, spread the plaster onto the surface, covering the strips of tape.

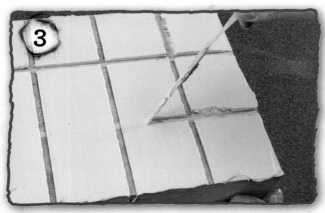

Smooth out the plaster as desired. For crisp, clean lines, pull the tape off immediately. If you want a rougher edge to your lines, let the plaster begin to set up for a few minutes and then remove the tape. Do not let the plaster completely cure, though, or you won't be able to remove the tape.

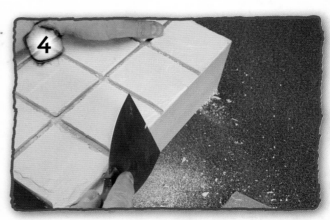

Once the plaster has hardened, scrape the edges with your trowel to remove any large chunks of plaster.

Use sandpaper to smooth the edges of the lines, if desired. It's okay to leave them rough if you want. The encaustic medium you will add later will help soften the edges.

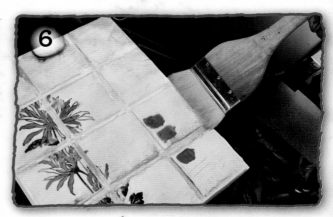

Paint and embellish the surface as desired. Allow the paint to dry. Brush heated encaustic medium over the entire surface, including the side of the box or cradleboard.

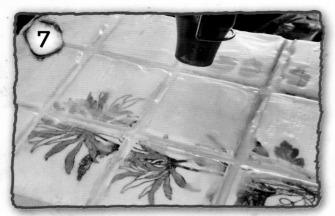

Use a heat gun over the entire surface to fuse the wax and to smooth out any brush marks.

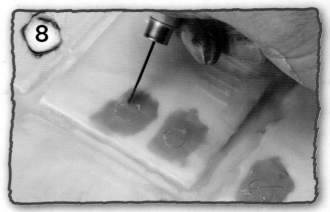

Using a carving tool, gouge interesting lines or texture into the wax.

With a paintbrush, apply Burnt Umber paint over the surface, working in small sections.

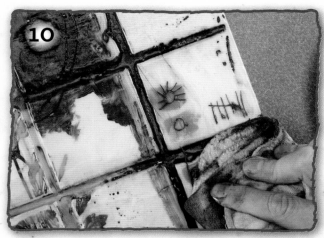

Immediately use a dry rag to remove the bulk of the paint from the surface and then follow up with a damp rag to remove the rest. The Burnt Umber paint will settle into the cracks and marks you made and will make the texture of the wax come alive with interest!

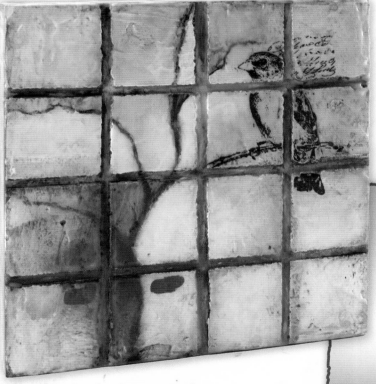

Nesting Instinct
Stephanie Lee and Judy Wise

This piece was a collaboration we completed after learning our book would be published. Stephanie started it by creating the substrate and painting the tree, and Judy finished it with added branches, transfers and wax.

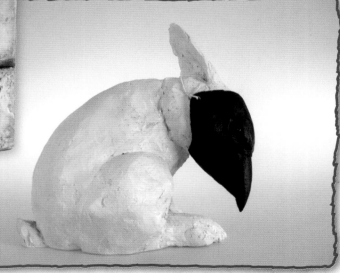

What Are You Afraid Of?
Darla Jackson

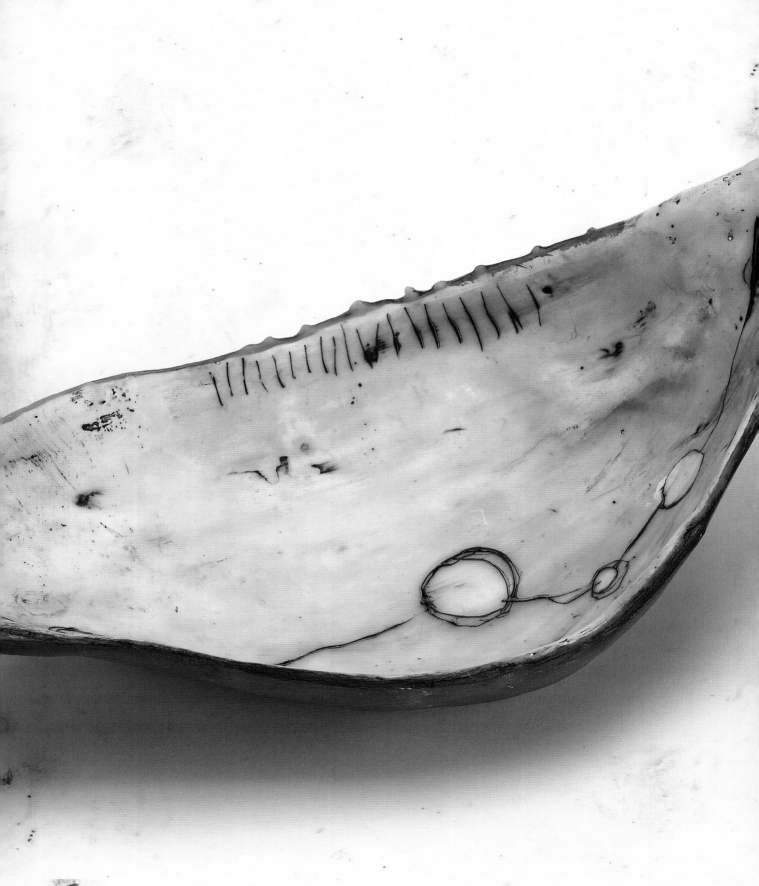

Sculpture

There is a play of light and shadow that can only exist through three-dimensional form. In this chapter, we are exploring a modern take on using plaster in sculptural form. Not only will we explore the various options of form and construction, we will also continue to explore the relationship between plaster and paint and how to use paint to enhance the sculpted form. With the right paint or wax treatment, plaster can be made to look just like bronze, carved wood and even a variety of stone.

The most important aspect of sculpting with plaster is to ensure that it is properly supported from within. A firm armature is essential for this support. A solid mass of plaster, which is then carved through subtractive techniques, is, of course, self-supporting. If you need a lighter-weight sculpture, however, a solid, heavy mass of plaster is not always a practical solution. This is where some basic hardware supplies and found objects become your most valuable tools.

Plaster will adhere to objects with a very porous surface but not to surfaces that are smooth and nonporous (such as glass or glazed ceramic). If you have found objects with smooth surfaces, be sure to wrap them in a layer of plaster gauze. The gauze won't stick well to the object directly but will stick to itself once it is completely encased. This initial exoskeleton of plaster gauze will allow subsequent layers of detail or smoothing plaster to adhere securely.

One option for creating a lightweight armature is to use Styrofoam or construction spray foam. Foam can be carved and shaped to whatever form you want. For a more open sculpture, you can create a wire armature that is simply and generously wrapped in plaster gauze, which can mimic twigs or delicate pottery.

Once you discover the ease with which you can translate plaster into three-dimensional form, your mind will expand to capacity with ideas! Let the expansion begin . . .

Foam Santo

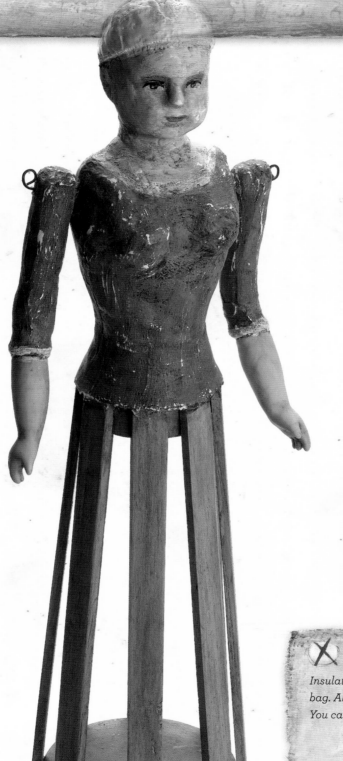

Plaster Prowess

Insulation foam can be sprayed onto a plastic bag. Allow it to dry and peel it off of the bag. You can cut it and use it in your projects.

All my life I've been fascinated by these cage dolls: the semi-creepy ceremonial figures that originated in Spain and Mexico. While the originals were serious objects of reverence, I just dreamed of having one to place on my dresser where I could drape her in my necklaces and hang my rings on her fingers. This little project will allow you to make a modern version of a santo (the female saints are properly called santas), spooky or sweet, painted or clothed in muslin or gauze, dipped in wax or not. She will brighten your mantle, keep your necklaces untangled or just make you smile.

—Judy

Materials

XXXXXXXXXXXXXXXX

thrifted doll head (look for porcelain or similar rigid type)

masking tape

spray insulation foam (Great Stuff)

brick of floral foam or a bowl of rice

santos cage doll base (resembles a skirt)

acrylic paints, assorted colors

paintbrushes

paper tube

hacksaw blade with a taped end for handle

sanding block

plaster gauze

tub of hot or warm water

19-gauge steel wire

wire cutters

wooden skewers, 2

bubble wrap

scissors

thrifted doll arms, 2

joint compound

soft rag

drill and ¹⁄₁₆" (2mm) bit

awl

needle-nose pliers

encaustic medium, hot pot, craft brush

heat gun

craft glue (optional)

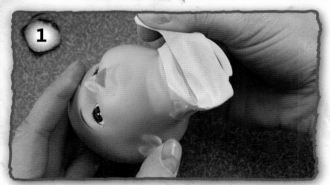

Cover the opening at the neck of the doll head with masking tape.

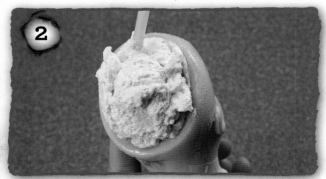

Prepare the spray foam according to the manufacturer's directions. Place the spray foam hose into the neck and spray it into the top of the doll's head to fill it with foam.

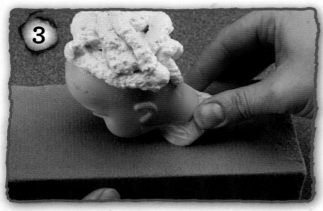

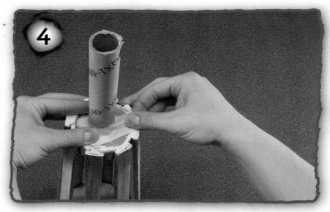

Press the filled doll head into the floral foam so it is level enough that the foam won't fall out. Alternatively, you can push the head into a bowl of rice. Allow the foam to set according to the directions on the can or overnight.

Prepare your base. Paint and antique as desired. Using masking tape, tape the paper tube to the top of the base. This will give the foam some structure and keep it from slumping.

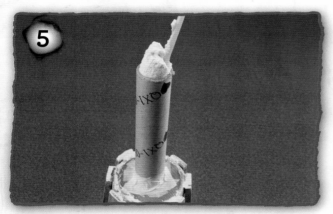

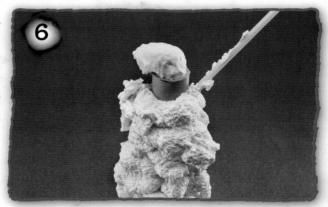

Fill the inside of the paper tube with spray foam.

Spray the outside of the tube with foam, turning to cover all around. You may need to do this in two layers. Allow the foam to set.

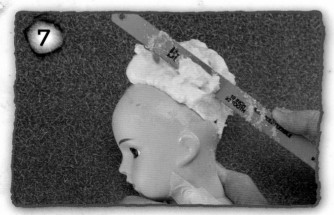

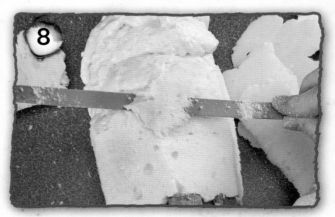

Using the hacksaw blade that has been partially wrapped in masking tape for a handle, sculpt the excess foam to create a round head shape.

Next, use the blade to carve the foam into a general form of the doll's torso.

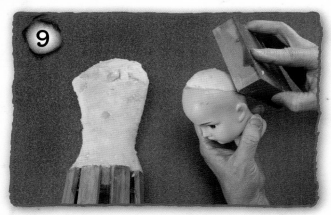

Sand the foam on the head and the torso to smooth and refine it.

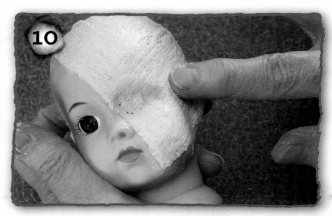

Tear off several pieces of plaster gauze from the roll. Dipping one small piece at a time into the tub of warm water, apply the gauze to the head.

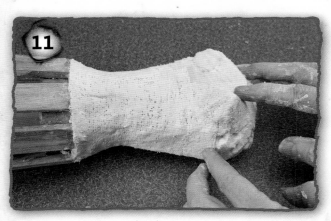

Repeat step 10 to apply plaster gauze to the torso.

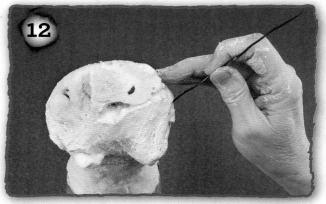

Cut two lengths of wire to about 6" (15cm). Push the wires down into the armhole areas at an angle before the plaster gauze completely hardens. If the wires need stabilizing, squirt craft glue directly into the wire holes and then reinsert the wires. Let the glue cure.

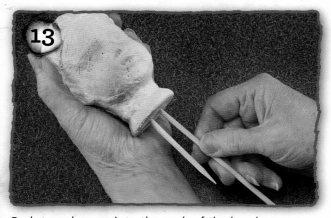

Push two skewers into the neck of the head.

✕ Plaster Prowess

Plaster gauze will not adhere easily to all surfaces, but it does stick to itself. When you are covering something with it, just be sure to have strips that are long enough to wrap around and overlap themselves.

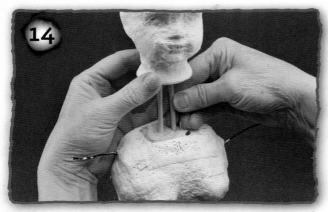

Push the skewered head into the top of the torso.

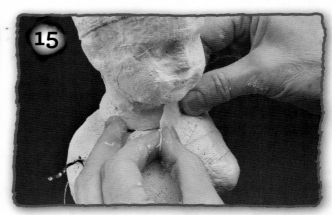

Apply small strips of wet plaster gauze around the neck to seam the two pieces together.

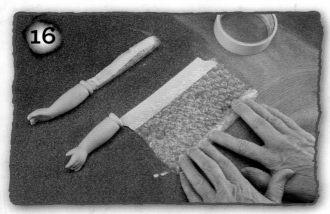

Cut two pieces of bubble wrap to about 5" (13cm) square. Place a piece of tape at one end of the bubble wrap. Roll the bubble wrap up and secure with the tape. Repeat for the other piece.

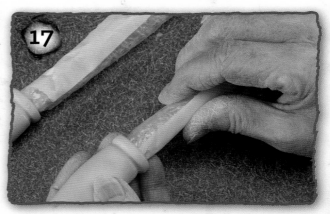

Stick one tube of bubble wrap into each doll arm.

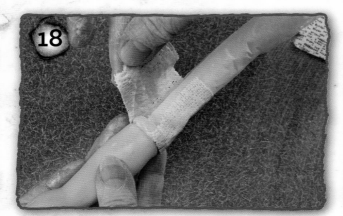

Wet a small strip of plaster gauze and wrap it around the area where the arm and the bubble wrap join.

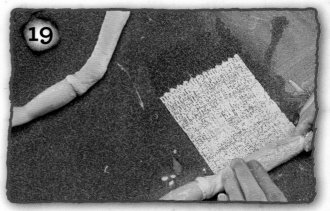

Continue plaster gauze up the length of the bubble wrap. If you want the arm to have a bend in it, bend the plaster portion while it is still wet and hold the shape until the plaster begins to set. Repeat steps 18–19 to complete the other arm.

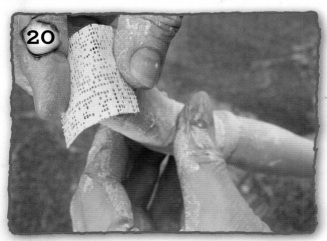

Cover the opening of each arm using a small piece of plaster gauze.

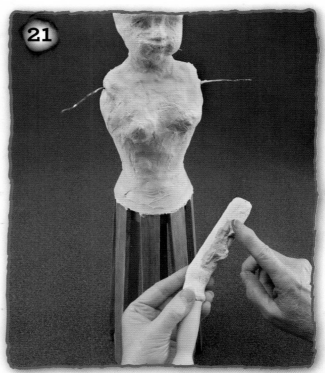

Using your fingers, smooth joint compound over the face, neck, body and arms. Allow the joint compound to dry. Apply as many coats as you think it needs to cover the texture of the gauze.

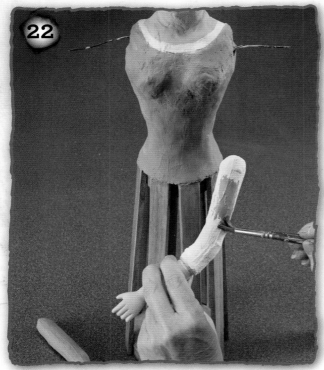

Paint the plaster elements as desired. Here I painted the torso and arms the same color as the base. The face is a flesh tone craft paint, and I added facial details. I then used a Burnt Umber color wash to age her, wiping the excess paint with a damp rag. Finally I sanded and distressed her.

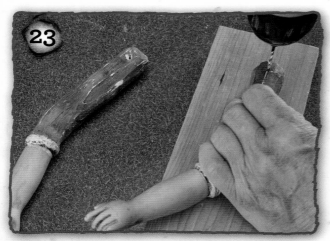

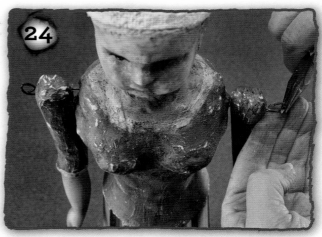

Drill one hole through the top of each arm, lightly drilling through the plaster shell. Then use an awl to puncture through the bubble wrap. You will want the hole about ½" (13mm) from the top of each arm.

Place the arms onto the wires that stick out of the torso. Using the needle-nose pliers, curl the remaining wire toward the body.

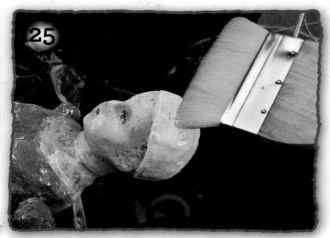

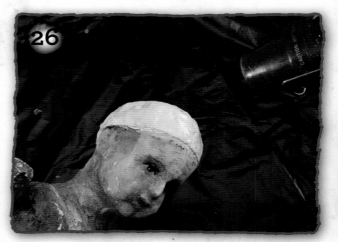

With the encaustic brush, apply encaustic medium to the plaster cap on the head.

Using the heat gun, fuse the encaustic to the head. Allow the wax to cool.

Nicho

Making structures like nichos and altars out of cardboard and plaster is easy, and the results are surprisingly sturdy. While I have freehanded the pattern for this nicho, you can also begin with a box or a partial box and add cardboard to it with the simple technique of using masking tape and your imagination. The dried plaster and joint compound will give your structure all the strength it needs. Just imagine all the forms and structures you can make by starting with this basic idea. Say welcome to your inner architect!

—Judy

Materials

XXXXXXXXXXXXX

pencil

corrugated cardboard

cutting mat

utility knife

masking tape

craft knife

plastic garbage bag

plaster gauze

tub of warm water

joint compound

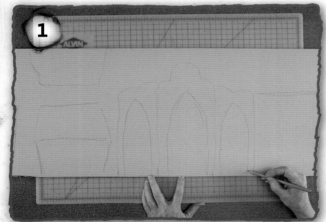

Using a pencil, draw your pattern onto the cardboard. Don't worry if your corners don't meet or the shape is a little wonky. This will add character, and you'll be surprised at how many defects will disappear under the plaster.

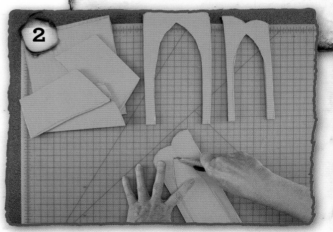

Place the cardboard onto a cutting mat. Use a utility knife to cut out the shapes.

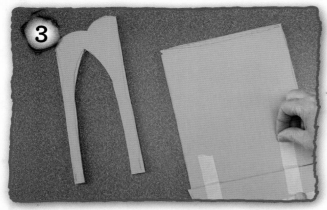

Tape two (or several more for added stability) of the identical trapezoid pieces together with masking tape for a deep and sturdy base. Then tape the back wall to the wide side of the base.

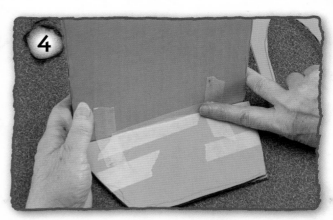

Place the back wall perpendicular to the base. Use tape to secure the back wall into its upright position.

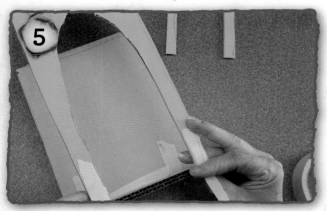

Add the front nicho piece to the base, securing with more tape.

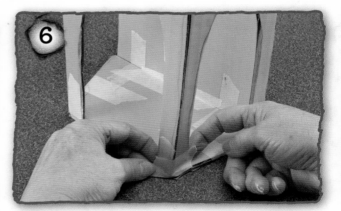

Put a few pieces of tape on your fingers. Secure one of the altar sides to the front and back.

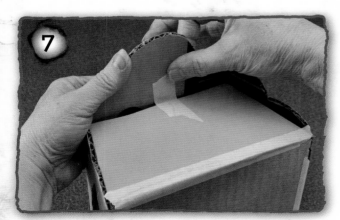

Repeat for the remaining nicho side. Add the remaining trapezoid shape to the top of the nicho.

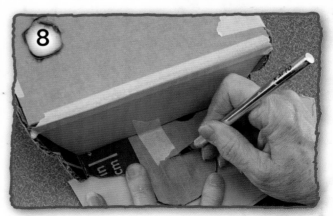

After building the nicho, use a craft knife to cut out a round window from the back side of the top front piece.

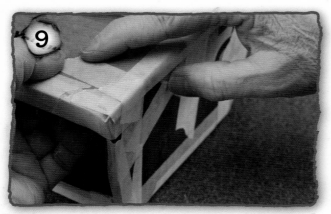

To help make the entire structure more stable, use masking tape to seal all of the cut edges.

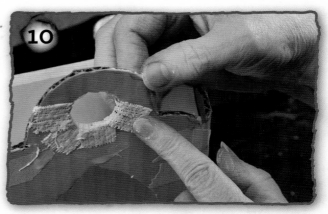

Lay out a plastic bag on your work surface and place the cardboard altar on it. Cut plaster gauze into various-sized strips. Starting with a small area, cover it in wet plaster gauze.

Layer the plaster gauze over the surface of the cardboard altar, going from smaller to larger spaces.

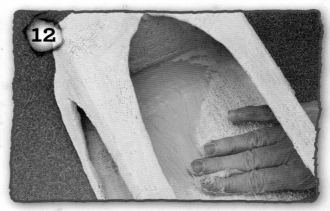

Cover every part of the nicho with plaster gauze and allow to set up. Using your fingers, apply the joint compound to all the surface areas. Be sure to get the joint compound into the corners and around the edges. Allow it to dry thoroughly.

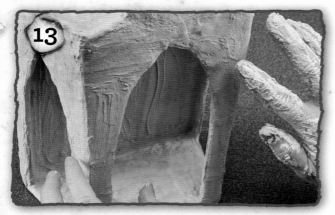

As you work, the joint compound will turn white. Use this to guide you where you might need more joint compound. Add as many layers as desired, allowing each layer to dry thoroughly. Add additional layers of joint compound to smooth out and refine the surfaces.

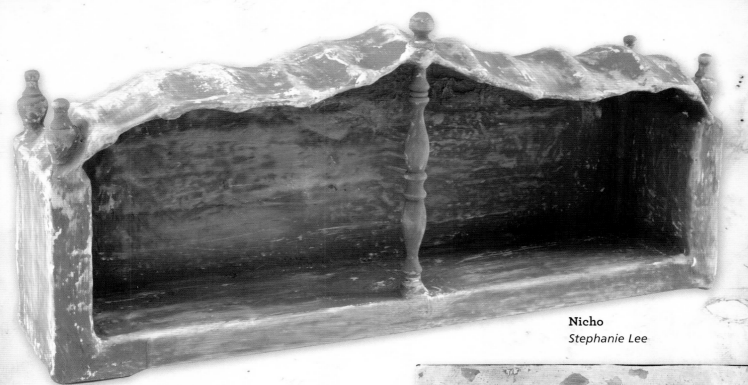

Nicho
Stephanie Lee

Gratitude
Stephanie Lee

Visitation
Judy Wise

Vessel

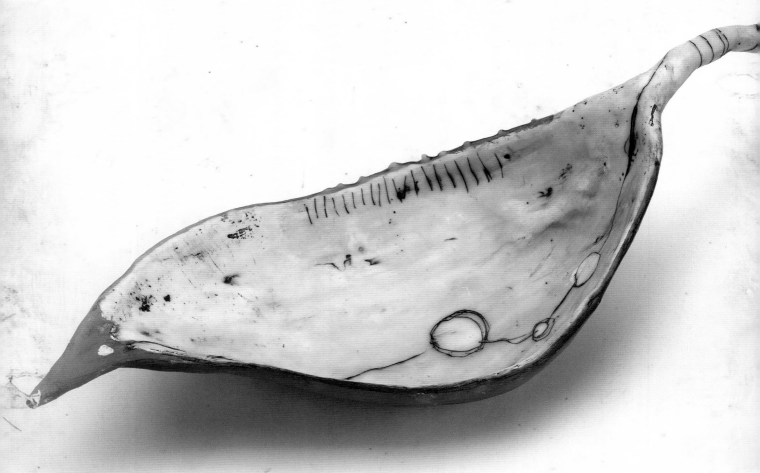

Years ago I spent a good amount of time working with clay. I loved the process of sculpting a form and guiding it through the evolution from chunk of clay to beautiful glazed bowl. I don't have easy access to a kiln anymore, so when I got the urge to create in clay again, I had to get creative and find an alternative.

Already familiar with plaster, I started there. I found that with a little effort to create the armature I wanted, I would soon have a claylike vessel within hours of starting. I fell in love with the technique and have used it to create many pieces of functional art.

Make whatever shape vessel you want—small or large, nesting or ones that can hang on the wall. Let it hold a collection of beautiful doodads you've been saving for years: heart rocks, jewelry or car keys. Take pride in your beautiful poor-man's pottery.

—*Stephanie*

Materials

XXXXXXXXXXXXXXXXXXX

19-gauge steel wire

heavy wire cutters

needle-nose pliers

masking tape

plaster gauze

tub of warm water

plaster of Paris

acrylic paints, assorted colors (including Burnt Umber)

paintbrushes

encaustic medium, hot pot, wide craft brush

heat gun

carving tool

soft rags

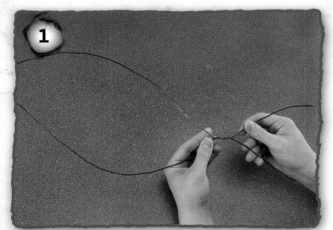

Using a long piece of wire (approximately 5' [1.5m]), form the outer shape of a leaf, twisting the two tails to secure the shape.

Continue twisting the tail pieces together to form a stem. Use needle-nose pliers to twist when the tails get too short to comfortably twist with your fingers.

At the tip of the leaf, crimp the bend a bit with the pliers to make a nice point.

Cut a new length of wire (about 3' [1m]) and make a loop at one end of it to secure it to the tip of the leaf. Crimp the two wires together with pliers to tighten the connection.

Begin wrapping the wire around one side of the leaf and continue for a few inches. Then bring the wire through the center of the leaf and secure it around the stem by twisting it.

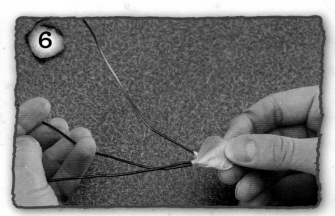

Use masking tape to reinforce the looped end.

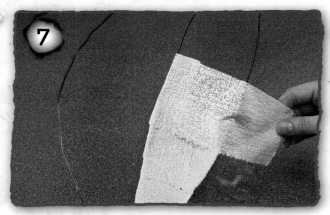

Cut some wider pieces of plaster gauze. Dip them in the warm water and then, beginning at one end, wrap the gauze around two of the wires.

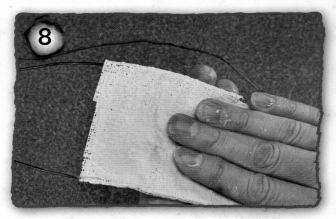

Overlap the ends of the gauze where you can and press it back onto itself. Repeat until one section is covered.

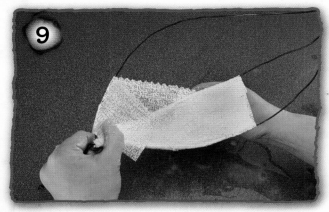

Continue covering the entire piece with the gauze. As you add each new piece, overlap it to a hardened piece of gauze already in place. This will "knit" all the pieces of gauze together.

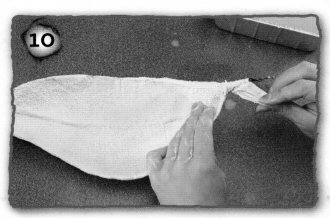

Wrap a bit of extra gauze on the stem to hide any wire ends and also to give it a bit more of an organic shape.

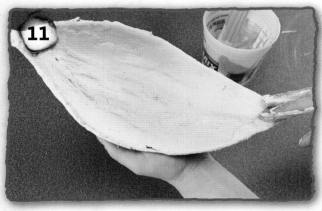

Once the plaster gauze has hardened but not fully dried (about 10–20 minutes), mix up a batch of plaster of Paris to about the consistency of frosting. Using your hands, spread the plaster all over the gauze to create a smoother surface. (If you like the texture and look of the gauze only, feel free to omit this step.)

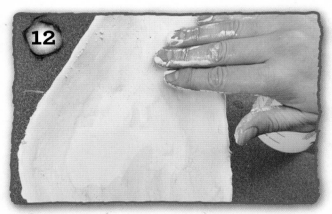

To remove any finger marks in the plaster of Paris, wet your fingers and lightly smooth the surface. Let the plaster cure completely. You will know it is fully cured when it is more white, lighter weight and doesn't feel moist or cold.

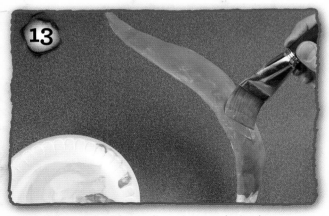

Paint the vessel with acrylic paints as desired. Here I painted the outside of the leaf green and left the rest raw plaster. Let the paint dry completely.

Plaster Prowess

If you find that the gauze is slumping more than you want as you are building the vessel or that the weight of the wet gauze is pulling the wire form out of shape, work in very small sections. Let the gauze harden before you work onto the next section. The vessel will become sturdier as the gauze hardens.

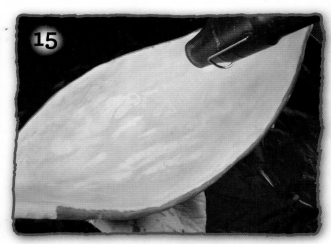

With a wide craft brush, paint hot encaustic medium on the portions you want covered. I chose to coat just the unpainted portions of the vessel for contrast.

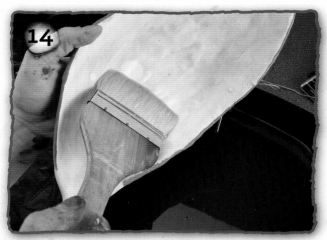

Fuse the medium to the plaster with a heat gun. Let cool.

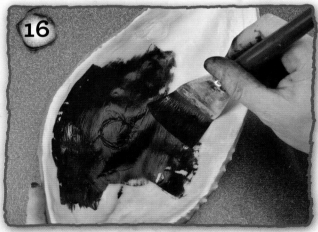

With a carving tool, make marks and gouges as desired. Paint over only the waxed area with Burnt Umber paint.

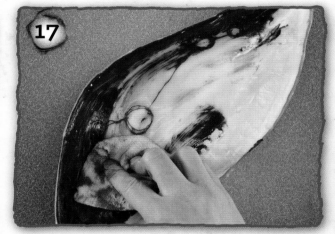

Quickly wipe the paint off with a dry rag. Follow up with a damp rag to remove the rest of the paint, leaving it only in the carved pattern and low places in the medium. Let dry.

Cage

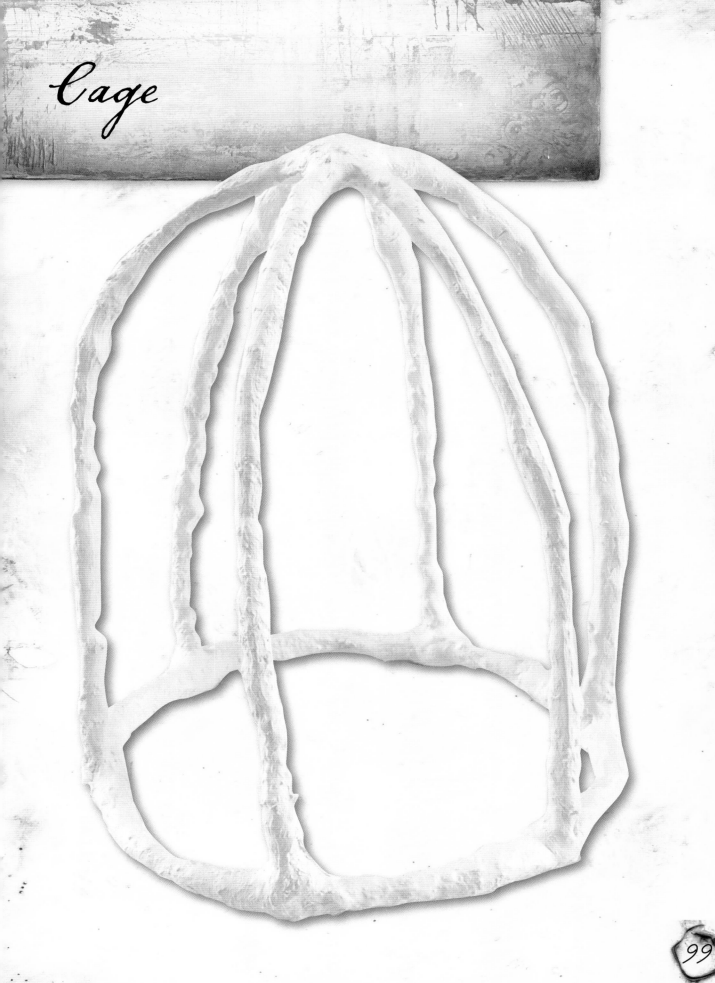

For quite a while now, I've had visions of a grouping of large cages hanging from my vaulted living room ceiling; their bone white shape in simple contrast to the warm, nutty wood ceiling. Some wired for lighting, dim bulbs casting dreamy shadows everywhere. I can just see them there . . . some square, some arched and rounded and shapely. Maybe even an open door in one or two.

I could add silk and vintage fabrics on lampshades, drawn taut and stitched on with colorful threads. Found objects could dangle like a chandelier cobbled together from beach finds.

Why stop at the ceiling? Why not take them to the wall too as an entire series of half-cages ready to mount as sculpture? With my penchant for houseplants and their tendency to flop over the edges of the pots, maybe even a cage-shaped trellis of sorts is in order as well.

—Stephanie

Materials

XXXXXXXXXXX

- 19-gauge steel wire
- wire cutters
- masking tape
- needle-nose pliers
- plaster gauze
- scissors
- tub of warm water
- acrylic paints and paintbrushes (optional)

Cut a piece of wire long enough to bend into the circumference you want the base of the cage to be. Tape the ends together to secure it and to cover the cut ends of the wire.

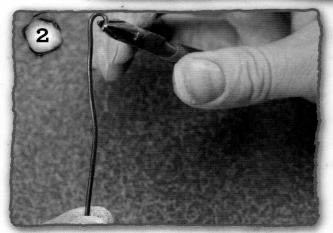

Cut three pieces of wire to a length that, when formed into a U shape, will be the height of the cage with a ½" (13mm) extra at each end. Using pliers, make a loop with each end.

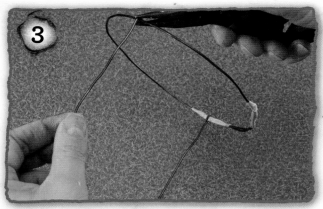

3 Hook the loop of one end onto the circle wire and use the pliers to pinch the loop closed. Repeat with the other end loop on the opposite side of the circle.

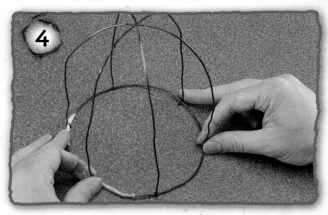

4 Repeat steps 2–3 with the other two wires. Adjust the shape as needed.

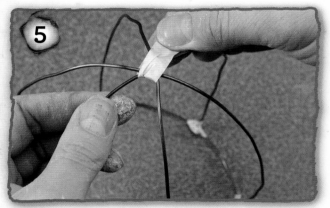

5 Secure the looped ends with small strips of masking tape to keep in place. At the top of the cage, add a strip of tape where the three wires intersect.

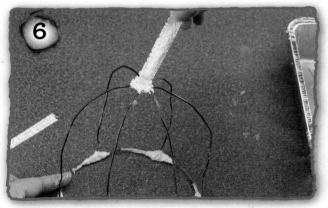

6 Cut a small strip of plaster gauze—about 1½" (4cm) wide and 6" (15cm) long. Dip in the warm water and wrap securely at the intersection point at the top of the cage just like you did the tape. Allow the gauze to harden for a few minutes. Repeat at the points where the loop ends attach to the base.

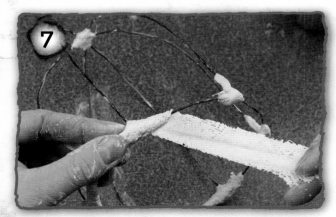

7 Cut more strips of plaster gauze that are a bit wider and longer. Dip in the water and, starting at a point where you have already wrapped gauze, hold the end of the new strip and wrap the rest of the strip on the bare wire between the two connections. Continue until the entire base is covered.

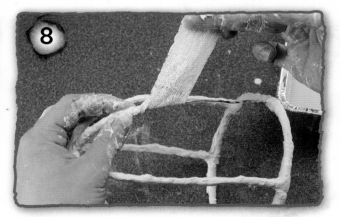

8 Repeat step 7 to cover the three U-shaped wires. The wrapping may be awkward at first, but if you wrap in the same direction as you go, you will keep all the wrapping secure. If the wrapping is lumpier than you like, let the gauze begin to harden up just a bit and smooth it out more with your fingers. Paint it or leave it white like I did.

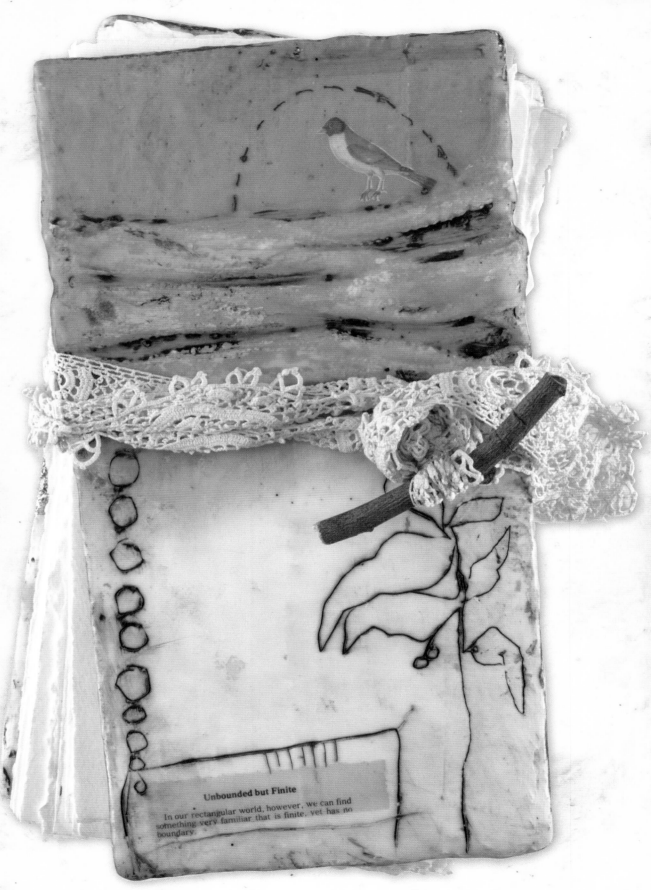

Unbounded but Finite

In our rectangular world, however, we can find something very familiar that is finite, yet has no boundary.

Book Arts

It's hard to find a medium that hasn't been altered, in some way or another, to be adapted for book arts. Leather, metal, fabric, paper and natural elements including bone, bark and leaf matter have all been manipulated and convinced to take on some sort of book form.

Generally, the purpose of a book is to record or contain something—writings, paintings, sketches. It would seem, then, that function would follow form (but not far behind, mind you, and sometimes not at all). A little thought and planning is all that is needed to make the rigid and brittle medium of plaster work for an object that will be opened and closed and handled endlessly. Because plaster alone has no tensile strength (a resistance to tearing or ripping, usually as a result of a fiber within the medium), you'll need to be creative with your modifications to ensure that the plaster components of your book are durable. By using plaster-impregnated gauze for pages and joint compound on the covers of rigid books, you'll be able to achieve the durability that is so valued when creating a handmade book form.

Plaster loves to receive a fluid medium. Its thirst for color and liquid makes it a perfect surface for the pages of a book—a term which can be used as loosely as you'd like. You'll find variations on the book theme in this chapter, and new ideas will be sparked exponentially as you add your own ideas to the mix, bringing a whole new meaning to the idea of judging a book by its cover.

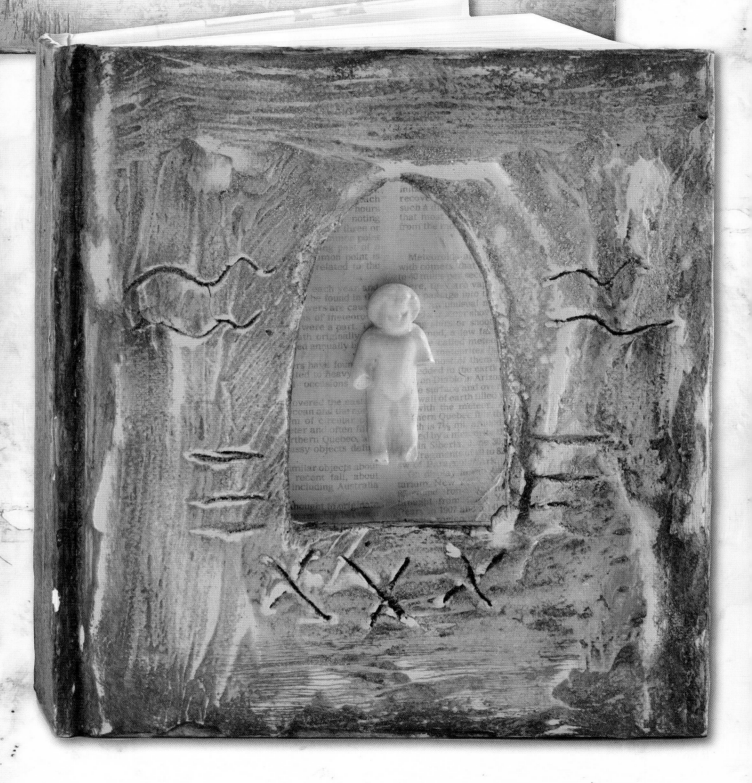

Plaster is a great choice for the cover of a book that has a nicho as its focal point. The texture of the plaster will have its own singular beauty, and the small cast object can be an item from nature (think shells, leaves, twigs) or an object that you love, as in the case of this small frozen Charlotte doll that I received as a special gift and didn't want to sacrifice. One of my favorite uses for these little recycled books is to house my painting-a-day works. Each book becomes a tiny, irreplaceable treasure.

—*Judy*

Materials

- polymer clay (Sculpey)
- small object to cast (figurine)
- plaster of Paris (including mixing container and paint stirrer)
- old pages from book
- pencil
- scissors
- hardcover book
- cutting mat
- utility knife
- carving tool or craft knife
- paintbrush
- acrylic gel medium, gloss
- palette (such as a disposable plate)
- acrylic paints, assorted colors (including white and Burnt Umber)
- damp rag
- sanding block
- craft glue

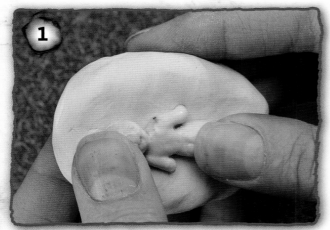

1 Condition the clay (work it in your hands to warm it up and make it pliable). Press the doll into the clay facedown.

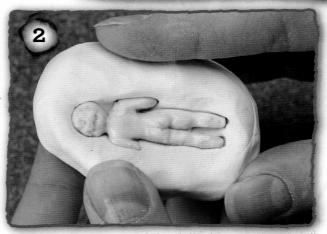

2 Work the clay up around the doll a bit to create a well.

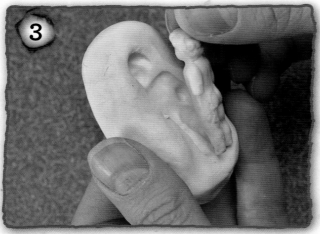

Carefully remove the doll, trying not to alter the shape of the depression in the clay.

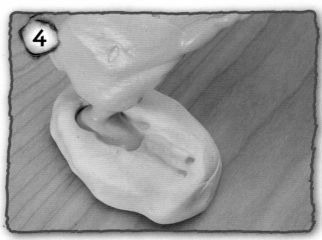

Mix up some plaster of Paris and fill the mold with plaster.

Let the plaster cure then carefully remove the figure from the mold. Lay the figurine on a sheet of paper the same size as the book cover and draw the desired shape of the window around the figure. This will be your window pattern.

Cut the window shape out from the page. Lay it on the cover of the book and trace around it.

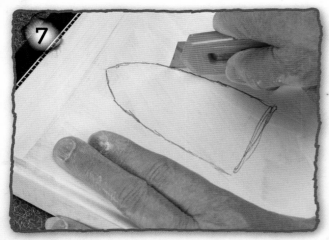

Slide a cutting mat between the cover and the book pages. Using a utility knife, cut out the window.

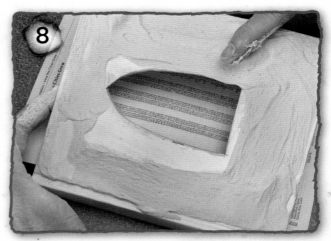

Mix up more plaster of Paris. The consistency should be that of stiff egg whites. Place a scrap of paper or spare book page between the cover and the pages. Using your fingers, apply the plaster to the cover.

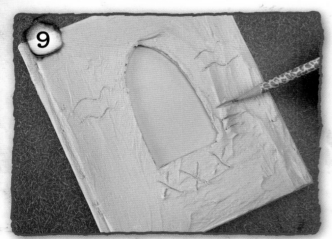

Using a pencil, create lines, symbols and/or texture in the wet plaster. Allow the plaster to dry.

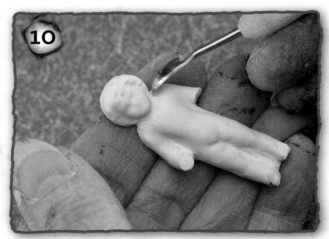

Using a carving tool or a craft knife, clean up the seam of the figurine.

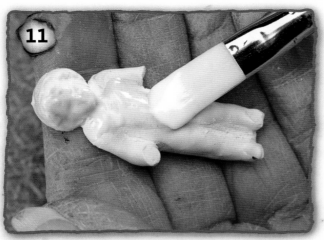

Using a paintbrush, apply gel medium (gloss) to the front of the doll to seal it. Allow the gel medium to dry.

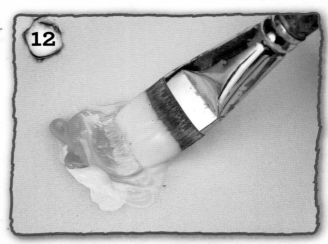

On your palette, mix some paint to use on the cover.

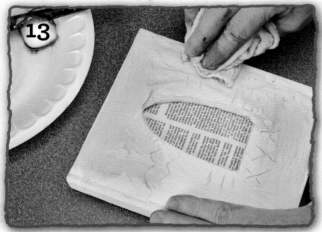

Place a piece of scrap paper between the cover and inside pages, and apply paint to the plastered cover. Remove excess paint with a damp rag.

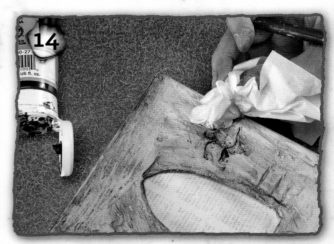

Apply Burnt Umber acrylic paint to the crevices and then immediately wipe the excess paint from the surface. Work on small areas at a time for the best control. After the cover is finished to your liking, paste a clean book page onto the first page so you like what is visible through the window. Apply a thin wash of white over that page.

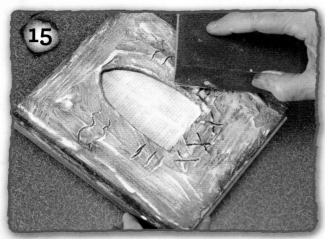

15

Sand the plaster cover using a sanding block. Remove the dust.

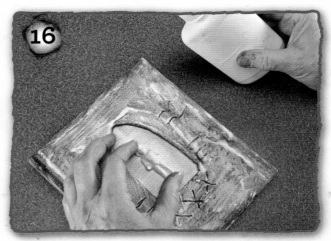

16

Glue the doll to the book page through the window, using craft glue.

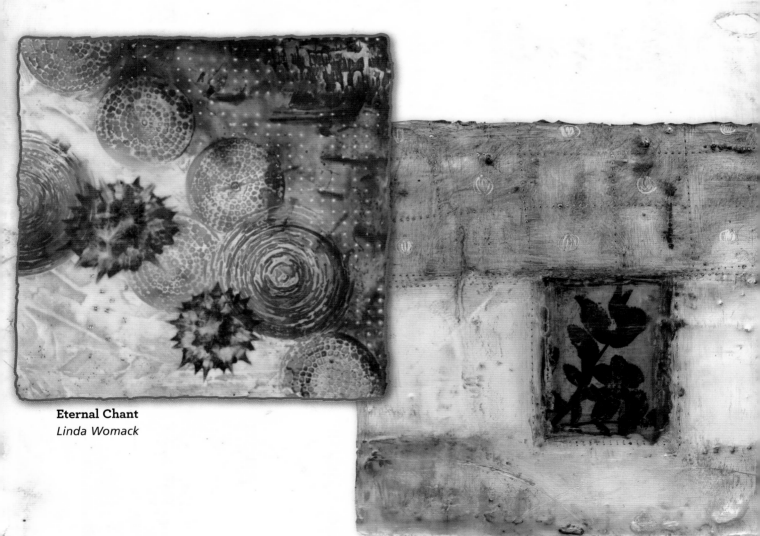

Eternal Chant
Linda Womack

Beneath the Prairie
Bridgette Guerzon Mills

Concertina

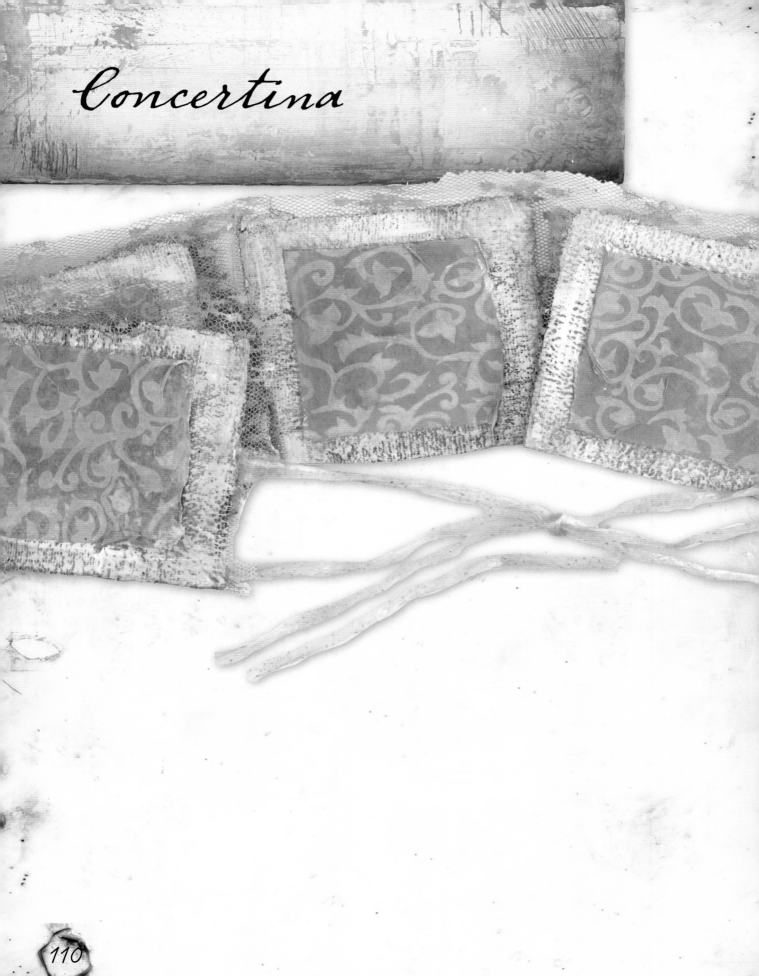

The technique shown in this project can be altered to a variety of patterns. You can create many pages to form a thick stack and fill it with handwritten poetry, or make just two pages and present it as a beautiful handmade card of sorts. Try making mini individual pages that you tuck in a pouch, or hang a strand of pages as you would a set of prayer flags. I've even imagined strips of pages stitched together to form a large curtain. How beautiful it would be hung in an east-facing window for the sunrise to filter through!

Just be sure to use a very open weave fabric so the plaster can adhere to itself through it. Also, don't worry if the pages seem to soften a bit when you are painting them. Once the paint has completely dried, the pages will become rigid and sturdy again.

—*Stephanie*

Materials

XXXXXXXXXXXXXX

plaster gauze

scissors

tub of warm water

plastic bag (such as a garbage bag)

roll of lace (slightly wider than desired page height)

fibers or fabric to use as tie

decorative paper

acrylic gel medium

craft brush

acrylic paints

wide paintbrush

Begin by cutting strips of dry plaster gauze to the width of your desired page size and twice the height. (Each strip will be folded vertically in half.) Wet one strip and lay it on the plastic bag. Lay the strip of lace horizontally on the bottom half of the gauze. This will be one of the ends of the concertina, so line up the right end of the lace to stick out just beyond the right side of the gauze.

Cut or tear two lengths of fabric or trim long enough to act as a tie for the finished booklet. Here, mine are about 18" (46cm) long. Set one end over the top of the lace, in the center of the bottom half of the gauze, so the rest of the strip goes off in the opposite direction of the lace.

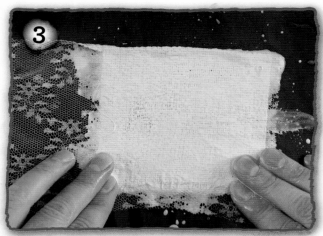

Fold the top half of the wet gauze down over the bottom half, encasing the lace and fabric strip. Smooth and press it with your fingers to make sure the two layers of gauze adhere together well through the lace.

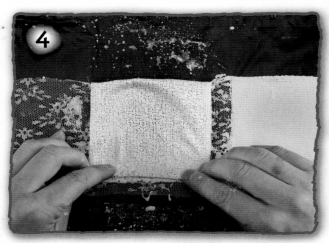

Moving to the left, leave about ½" (13mm) of space along the left edge of the folded gauze strip. Then place another wet piece of gauze under the lace, folding the top half down over the lace to create another folded page. Continue doing this for as many pages as desired.

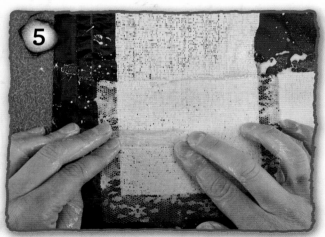

When you reach the final page, add your second strip of fabric on top of the lace, going out to the left, before you fold the top half of the gauze down. Let the gauze dry.

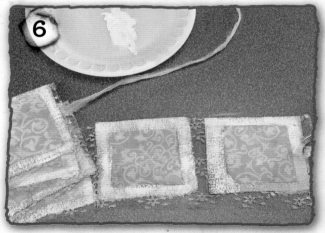

Cut pieces of paper about 1" (3cm) smaller than the gauze page size. Using gel medium and a craft brush, glue the papers to the centers of the pages. Allow the medium to dry. Apply a color wash over the entire concertina and allow the paint to dry. Embellish further as desired.

[Untitled]
Judy Wise

[Untitled]
Patricia Larsen

113

Wire-Spine Pages

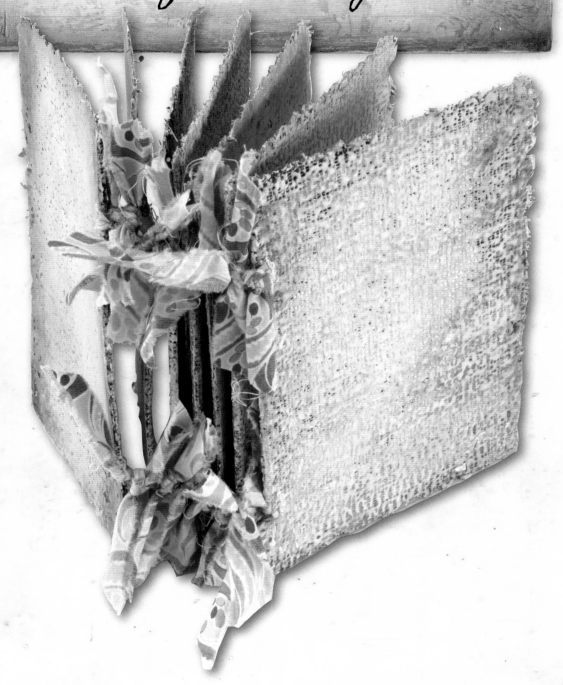

I love the idea of incorporating plaster into the book arts—specifically into the pages of handmade books. Because plaster receives paint and collage so readily, I just knew it would be a perfect fit if the construction could be figured out in a way that would result in sturdy pages that would hold up to a good amount of wear and tear.

Plaster gauze was the solution. It is strong, yet thin, and still remains a bit pliable when combined with watercolors or other fluid mediums. As long as you reinforce the spine with thin wire so you don't tear through the fibers of the gauze, you can bind up these pages with a variety of joining techniques including traditional single-sheet bindings.

—Stephanie

Materials

- plastic bag (such as a garbage bag)
- plaster gauze
- scissors
- tub of warm water
- craft wire (between 18- and 20-gauge)
- wire cutters
- acrylic paints, Burnt Umber and white
- wide paintbrush
- damp rag
- smaller paintbrush
- cutting mat
- utility knife
- fabric strips, ribbon or other trim
- beads or found objects (optional)

Spread the black plastic bag over your work surface. Begin by cutting pieces of plaster gauze to the desired number of pages. Each gauze piece should be twice the desired page width by the desired page height. (The gauze pieces will be folded in half horizontally.) Also, cut lengths of wire about ½" (13mm) shorter than the finished height of the pages. Cut one wire per page. Finally, cut small strips of gauze that are the height of the page × about 1" (3cm). Again, one strip per page. Hold one wire in the center of one of the small strips and dip in the water.

Fold the strip over the wire and dip it back in the warm water. Press the strip on the wire to tuck the wire into the fold.

Crease one plaster page in half horizontally and then unfold.

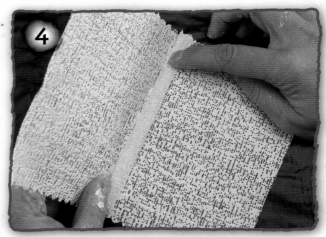

Place the wire strip in the crease of the gauze page so that when the page is refolded, the wire is in the crease.

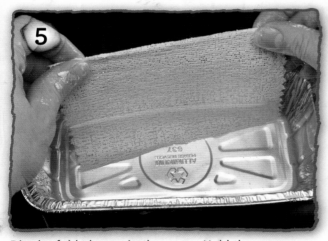

Dip the folded page in the water. Hold the crease where the spine wire is and let it hang for a second to make sure the wire is tucked into the crease as much as possible.

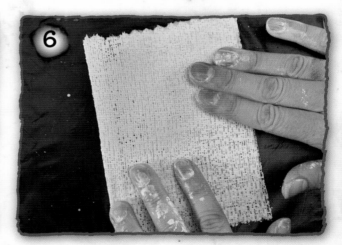

Lay the folded gauze on the plastic bag. This is now one of the pages. Burnish the page a bit with your hand to make sure the folded portions are well bonded. Repeat this process until all of your pages are done. Lay each page on the plastic bag to dry.

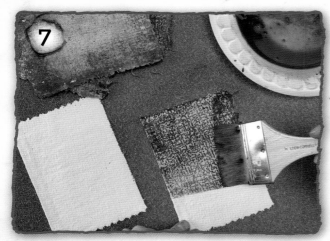

Create a wash with Burnt Umber paint and water (about 1 part paint to 3 parts water). Using the wide paintbrush, paint both sides of the plaster pages.

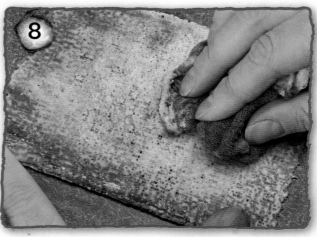

Using the wet rag, wipe the paint. This removes and blends some of the paint with the plaster, adding visual texture. Allow the paint to dry.

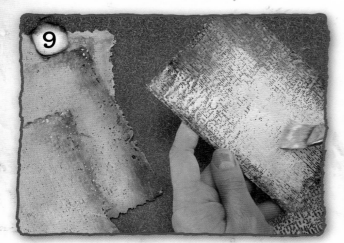

Apply white paint to the center of each page, blending it out toward the edges.

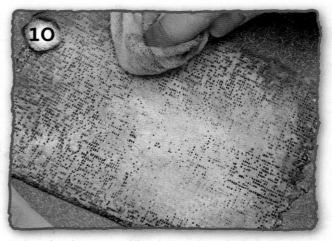

Using the damp rag, blend the edges further. Repeat with all the pages.

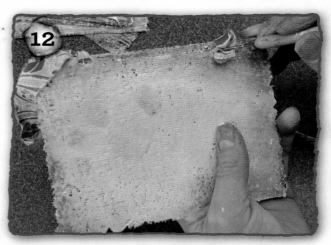

When all the pages are dry, place each page on a cutting mat. Using the utility knife, make two slits in the page, very close to the spine wire and about 1" (3cm) from the top and bottom edges. The strips should be in the same place on each page and slightly longer than the width of the fabric strips so the strips can be pulled through.

Cut two 8" (20cm) fabric strips, or ribbon, per page. Thread a fabric strip through the slit in one of the pages. (Use a tool to push the fabric through if necessary.) Repeat for the other slit with a second fabric strip.

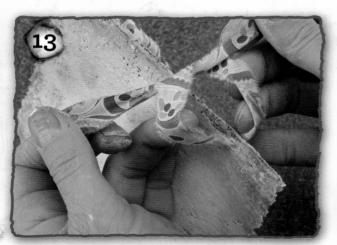

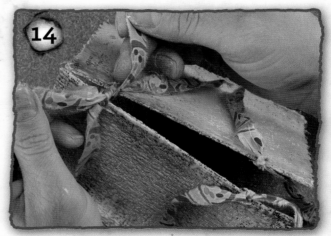

Center the fabric strips through the slits to make them even on both sides of the spine. Tie the fabric strip flush to the page. Repeat for the remaining pages.

Tie two pages together using one end of one tie on one of the pages and one end of one tie on another page. Knot tightly. Repeat for the other strip on that page.

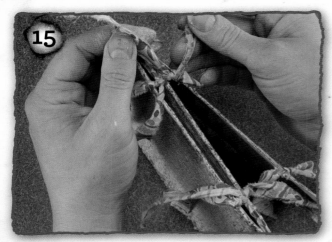

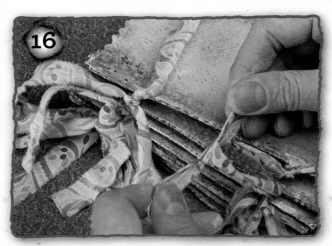

Line up the next page and use the unused loose tie from the previously tied pages to tie to one end of one tie on the new page.

Repeat step 15 for all the pages until you have a securely knotted stack of pages. Trim the ties as desired. At this point, you could add beads or found object elements to the ends of the ties for interest.

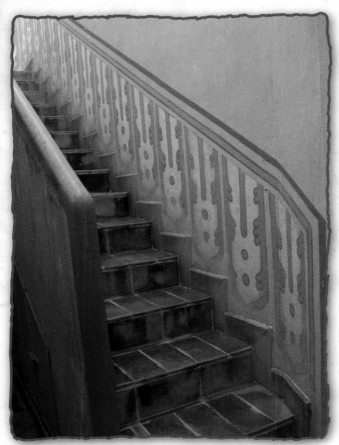

Limewash Painted Stairwell
Amber Eagle

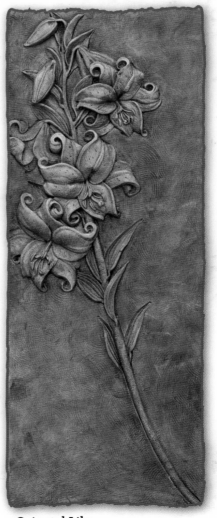

Oriental Lily
Patrick Gracewood

Poetry Folio

Unbounded but Finite

In our rectangular world, however, we can find
something very familiar that is finite, yet has no
boundary.

Traditional book-binding can be intimidating to the novice bookmaker. It can discourage some curious, but unsure, creative types from diving into the diversity of book arts.

This project is perfect for someone who wants to start creating book-like format pieces without any knowledge (or patience—that's me) of traditional stitching techniques. All you are creating in this project is a front cover, back cover and stack of whatever you want to tie between the two. Feel free to add fabric, vintage ephemera elements, photos, original art or poetry between the pages. To "bind" the stack together, I just used a piece of scrap lace trim with a stick tied to one end. I wrapped the other end of the lace around the stick to secure it and, voilá, a beautiful stack of art!

—Stephanie

Materials

- plaster gauze
- scissors
- tub of warm water
- corrugated cardboard, 2 same-size pieces
- acrylic paint, assorted colors (including white and Burnt Umber)
- paintbrushes
- damp rag
- collage elements
- acrylic gel medium
- encaustic medium, craft brush, hot pot
- heat gun
- scribe or carving tool
- fabric strip, ribbon or trim
- twig (optional)
- paper for interior pages

1

Cut a stack of large gauze pieces. Begin dipping them in water and laying them on one of the cardboard pieces.

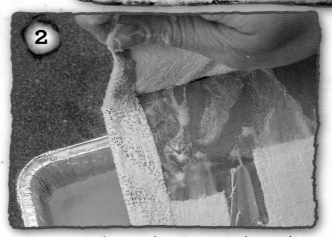

2

Layer on some pieces so the gauze extends over the edges of the cardboard and wrap the gauze pieces around to the back. At the corners, first fold the plaster gauze over onto the cardboard, and then crease and fold down to the face of the cardboard. Continue adding gauze until the entire piece of cardboard is covered in 2–3 layers everywhere or to the desired thickness.

Use your fingers to smooth out the gauze as it begins to harden.

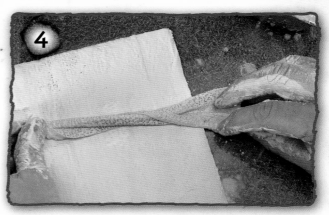

Repeat steps 1–3 for the other piece of cardboard. Cut a strip of gauze slightly wider than the width of your cardboard piece. Dip it in the water and then gently twist it and lay it on the face of one of the cardboard pieces.

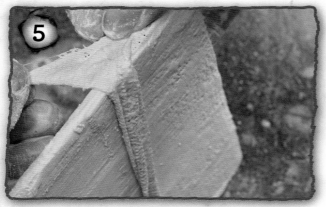

Spread the ends of the twisted piece and wrap around the back of the cardboard piece to keep them thin and to blend with the existing gauze.

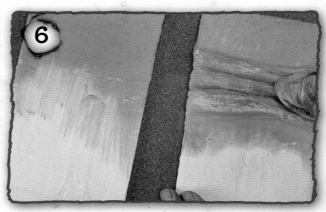

Use your fingers to mold and smooth down the twisted plaster strips as desired. Repeat for a couple more twisted pieces and let them dry. Paint half of the cardboard pieces on what will be the outside covers. I'm using green and white. If desired, blend and soften the paint with a damp rag and also remove it from the high places on the gauze.

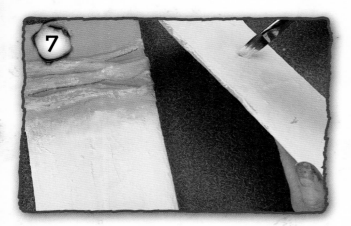

Paint the other ends of the covers and the back with white paint. (This may seem redundant over the top of white plaster, but it's an important step because we'll be using encaustic medium later, which reacts differently to the paint than the raw plaster.) Blend the area where the white and green meet with a damp rag. Allow the paint to dry.

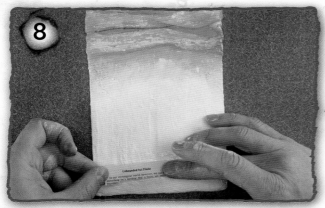

Gather the desired collage elements. Using gel medium, apply the collage pieces to the surface as desired. I used my fingers to apply the medium, but you can use a paintbrush. Allow the gel medium to dry.

To seal the covers, use a craft brush (or dedicated encaustic brush) to brush heated encaustic medium over the surface of each piece.

Use a heat gun to evenly fuse the wax into the painted plaster. Let the wax cool.

Using a scribe or carving tool, create texture or draw simple shapes into the cooled wax. Paint over the covers with Burnt Umber paint. Use a wet rag to wipe the paint from the surface, leaving paint incised in the crevices.

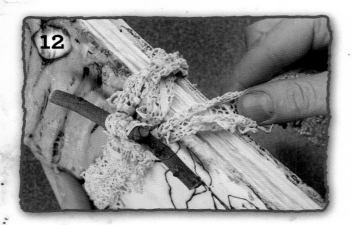

To make the book, cut or tear paper to a size just shy of the covers. Assemble the pages, placing a cover on each side of the stack. Use a sturdy piece of fabric or trim to wrap the folio shut. There is no need to attach the fabric other than wrapping. I used a twig to tie the trim around.

Resources

DAP

www.dap.com
joint compound (regular or lightweight),
plaster of Paris

DICK BLICK

www.dickblick.com
plaster cloth (plaster gauze)

NOVA

www.novacolorpaint.com
acrylic paints, mediums

DANIEL SMITH

www.danielsmith.com
extra-fine watercolor paints

GOLDEN ARTIST COLORS, INC.

www.goldenpaints.com
soft gel (gloss) medium, fluid acrylic paints,
polymer varnish

WINSOR & NEWTON

www.winsornewton.com
watercolor paints, acrylic paints, mediums,
varnishes

DADANT & SONS

www.dadant.com
white cake beeswax

SWANS CANDLES

www.swanscandles.com
natural white beeswax pellets

UTRECHT

www.utrechtart.com
Singapore damar crystals

SOFT EXPRESSIONS

www.softexpressions.com
Gold Jones Tones gold foil paper (heat-
applied Mylar sheet)

STABILO

www.stabilo.com
Stabilo Aquacolor black pencil

ELMERS

www.elmers.com
wood glue

3M

www.3m.com
two-part epoxy

IWATANI

www.iwatani.com
large flame butane torch (model CB-TC-PRO)

MAG-TORCH

www.magtorch.com
medium flame propane torch
(model MT 535 C)

BERNZOMATIC

www.bernzomatic.com
small-flame micro torch

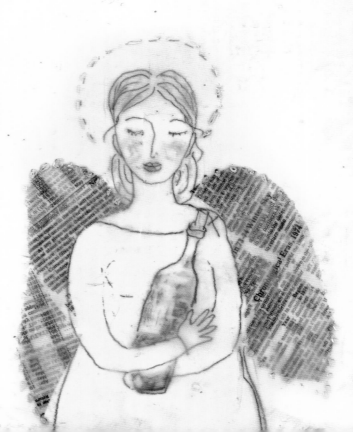

Contributing Artists

SETH APTER
www.thealteredpage.com

JILL BERRY
www.jillberrydesign.com

RO BRUHN
www.robruhn.blogspot.com

AMBER EAGLE
www.ambereagle.org

PATRICK GRACEWOOD
www.gracewoodstudio.com

BRIDGETTE GUERZON MILLS
www.guerzonmills.com

LYNNE HOPPE
www.lynnehoppe.blogspot.com

DARLA JACKSON
www.darlajacksonsculpture.com

ISABELLE JOHNSTON-HAIST
isabelle@johnston.ch

KATIE KENDRICK
www.katiekendrick.com

PATRICIA LARSEN
www.patricialarsen.com

HEIDI PETERSEN
www.heidipetersen.com

STEPHANIE RUBIANO
www.stephanierubiano.com

PATRICIA WHEELER
www.patriciawheelerart.com

LINDA WOMACK
www.lindawomack.com

Index

About Stephanie and Judy

Stephanie Lee

Stephanie Lee creates art (and messes) in the studio of her Oregon home. She knows the power of creativity. She knows that the gift of being able to make art brings people back to the center of their innate creativity and helps them live more authentically in the world. She knows that for every creative inkling honored, there are countless dormant forces that awaken to support the effort. She loves learning for learning's sake and sharing what she knows with others as much as humanly possible. When she's not traveling to teach, she's experimenting with new ideas in metal and plaster smithing, writing, wrangling wild ponies—otherwise known as her two children—and digging in the garden soil. Sometimes all at once because life is too sweet to not let the juices of it drip all over the place.

Judy Wise

Judy Wise is an Oregon artist, writer and teacher whose work has been published over several decades in books and periodicals, on greeting cards, textiles, educational materials and calendars, and in the gift industry.

She is prolific and inventive, keeping daily journals of her writing and art since childhood and finding fascination in many divergent art-related areas.

She knows that art saves lives, that people who make art are more interesting than people who don't and that everyone can be creative if they are adventurous. She is a passionate lover of all things artful and of helping others find joy in the process of self-expression.

Discover more inspiration with these North Light titles.

www.CreateMixedMedia.com

The online community for mixed-media artists

techniques • projects • e-books • artist profiles • book reviews

For inspiration delivered to your inbox and artists' giveaways,
sign up for our **FREE** e-mail newsletter.

Flavor for Mixed Media
Mary Beth Shaw

Are you as passionate about food as you are about making art? Join author Mary Beth Shaw as she invites you to a mixed-media "dinner party" where you'll mingle with inspiring guest artists. As you sample the tasty offerings, you'll be presented with chapters focusing on color, texture, layers, flavor and combinations—the same topics you find in cooking. Working with stencils, carving into substrates and developing your own color palette are just some of the techniques you'll learn to adapt to your own art-making in this inspiring and delectable book!

ISBN-13: 978-1-4403-0317-3 • ISBN-10: 1-4403-0317-7 • paperback • 128 pages • Z6944

Semiprecious Salvage
Stephanie Lee

Create clever and creative jewelry that tells a story of where it's been, as metal, wire and beads are joined with found objects, some familiar and some unexpected. You'll learn the ins and outs of cold connections, soldering, aging, using plaster, resins and more, all in the spirit of a traveling expedition.

ISBN-13: 978-1-60061-019-6 • ISBN-10: 1-60061-019-6 • paperback • 128 pages • Z1281

Surface Treatment Workshop
Darlene Olivia McElroy and Sandra Duran Wilson

The authors of *Image Transfer Workshop* have returned to your studio, and they've brought with them more than 45 stepped-out painting and layering techniques to tempt your muse. Projects that combine the techniques into finished works of art give you even more inspiration, and extensive examples from both artists show how the same techniques can be used to yield very different results. Discover endless applications for your favorite paints and mediums.

ISBN-13: 978-1-4403-0824-6 • ISBN-10: 1-4403-08241 • paperback • 128 pages • Z8042

These and other fine F+W Media titles are available from your local craft retailer, bookstore, online supplier, or visit our Web site at
www.CreateMixedMedia.com.